Mastering HD Video with Your DSLR

Mastering HD Video with Your DSLR

Helmut Kraus, Uwe Steinmueller

Helmut Kraus (helmut.kraus@exclam.de)
Uwe Steinmueller (ustein_outback@yahoo.com)

Editor: Gerhard Rossbach
Copyeditor: Catherine Viel
Translator: Jeremy Cloot
Layout and Type: Almute Kraus, www.exclam.de
Cover Design: Helmut Kraus, www.exclam.de
Printer: Friesens Corporation, Altona, Canada
Printed in Canada

ISBN 978-1-933952-60-4
1st English Edition
© 2010 Helmut Kraus, Düsseldorf, Germany.
Title of the German original: HD-Filmen mit der Spiegelreflex
Translation © 2010 by Rocky Nook. All rights reserved.
16 15 14 13 12 11 10 1 2 3 4 5

Rocky Nook
26 West Mission Street Ste 3
Santa Barbara, CA 93101-2432
www.rockynook.com

Library of Congress Cataloging-in-Publication Data

Kraus, Helmut.
 [HD-Filmen mit der Spiegelreflex. English]
 Mastering HD video with your DSLR / Helmut Kraus, Uwe Steinmueller ; [translator, Jeremy Cloot]. -- 1st English ed.
 p. cm.
 Includes index.
 ISBN 978-1-933952-60-4 (alk. paper)
 1. Digital cinematography. 2. Digital video. 3. High definition video recording. 4. Single-lens reflex cameras. 5. Digital cameras. I. Steinmueller, Uwe. II. Title.
 TR860.K7313 2010
 778.5'3--dc22
 2010005925

Distributed by O'Reilly Media
1005 Gravenstein Highway North
Sebastopol, CA 95472

Contents

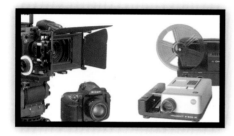

Foreword

by Helmut Kraus

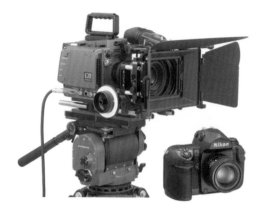

Many photographers will be asking themselves why they should use their DSLRs to shoot video at all. Perhaps this is just the marketing people's latest clever strategy? The most obvious reason to do so is "because you can", but there are other reasons, too, for using the same camera to shoot photos and video. Both activities satisfy the human need to communicate visually, and both media enhance and extend human perception of time, space, and aesthetics.

Nowadays photographers and filmmakers no longer have to decide in advance what form their finished work will take. A DSLR can be used to shoot both stills and video, and both media can be mixed at will when presenting the results on a computer screen or using a projector.

We are currently witnessing the birth of a new medium which combines the advantages of both conventional art forms, creating a new, potentially more powerful hybrid.

Technology

The simple reason so many camera manufacturers are suddenly offering HD video functionality in their products is that it is relatively cheap and easy to do so. The ever-increasing sensitivity and resolution of image sensors make shooting video a snap, although the processors built into today's cameras have also had to develop in step in order to process the huge volumes of digital information high-resolution sensors produce.

But the really important development that made shooting digital

video popular was the increase in speed and capacity (and the decrease in price) of memory media. Video data requires large amounts of memory: one minute of HD video requires between 80 and 150 MB of memory, and a single minute of Full HD footage can use as much as 256 MB.

Compact and bridge cameras began to fulfill these important criteria several years ago, and many older compacts have a built-in video mode, usually only capable of shooting in VGA quality. The DSLRs available back then didn't have video functionality at all. One reason for this was the developers' concentration on popularizing digital photography—video functionality was seen more as a gimmick than a feature that would convince serious photographers to abandon analog photography in favor of the new, digital medium. One technical reason for the delay was the simple fact that a DSLR has to raise its mirror during an exposure to allow light to reach the image sensor. In order to shoot video sequences, the mirror would have to be raised for the entire shot, and the photographer would be unable to follow the action being recorded. The advent of so-called "Live View" functionality was the crucial step. For the first time, the photographer was able to view a constant monitor image, even with the mirror raised and the viewfinder dark.

Live View works in exactly the same way when shooting photos or video.

The parallels between the two media are not really new, and the conventional photography and film worlds have always shared the same recording medium. A press photo shot using a Leica was quite possibly recorded on exactly the same 35mm film material as an entire documentary film. Today, technology has come full circle and enables us to shoot photos and video using the same camera and a single image sensor.

Aesthetics

So—we use our DSLR to shoot video because it is technically possible. But does it actually make sense to do so? Every photographer has to answer this question for himself, but the basic idea is certainly more appealing than toting an SLR and a video camera in every shooting situation. Constantly having to use two completely different tools to record two different types of media is a challenge, and often results in low-grade results for both. Budget is also a limiting factor that prohibits the parallel use of two separate media. Nowadays, the basic question is a lot simpler: do I set the dial to photo or video mode?

New technology has led to the birth of new, hybrid shooting techniques, even in the world of professional movie making. A well-known

example is the so-called "Matrix Effect" (named after the famous Wachowski Brothers film), in which the camera appears to fly around the scene in extreme slow motion. This effect is produced by setting up a large number of (stills) cameras around the scene and taking a long series of slightly time-delayed shots that are subsequently merged into a single movie sequence.

Every photographer at every level has at some point realized that the limits of the medium have prevented him from achieving his intended result. Newer techniques allow a photographer to circumvent these limits; for example, merging multiple images into a single panorama image can help you to work around the limited angle of view of a conventional lens.

A video-capable DSLR allows you to replace a panorama with a pan, or to capture a moving subject more meaningfully than a motion-blurred (or super-sharp) photo can.

But the most convincing reason for using a DSLR to shoot video is probably the ability to shoot video that looks like film. You can now capture video with a photographically broad tonal range, and with equally sharp detail in bright backlit or shadow situations. Videos shot using conventional video cameras have much greater contrast, and consequently a much narrower tonal range. Many

video-based filmmakers and artists use this video "look" deliberately. Speaking as a photographer, if I really need to produce a video-style effect, I prefer to generate it using a software-based change in tonal values rather than limiting myself at the shooting stage. Remember, footage shot using video equipment can never be processed to look like film, and tonal values that are not present in the original material cannot be produced artificially later.

Presentation

In the analog world, photos and film were always presented separately. Most photos were either exhibited as prints or published in print media, and slide shows provided a way of presenting still images to a larger audience. Slide and film projectors are completely different devices, and the two media developed largely parallel to one another until TV began to merge still and moving images.

The digital age has seen a significant move from paper-based to monitor-based presentation of photos, whether on a computer, a mobile phone, an iPod, or using the camera itself.

The fact that digital photos and video can be presented using one and the same device is another good reason for experimenting with moving pictures shot on your DSLR.

Although film and photo equipment
(and professional training) are still
quite different to one another, they
are—viewed historically—closely
related, and have strongly influenced
each other's development over the
years. Photography only became an
interesting and affordable hobby
when Oskar Barnack came up with
the idea of using comparatively cheap
35mm movie film in stills cameras.

We are currently witnessing what
could be the start of the total fusion
of the film and photo media. We
already have the cameras and presen-
tation media that can handle both.
Now all we have to do is get on with
breaking down the existing barriers.

Basics

by Helmut Kraus

Normal 8, Super 8, 16mm, 35mm, CinemaScope, 70mm, Panavision—these are just some of the huge range of shooting formats available in the analog movie world. Unfortunately, things are just as confusing in the new, digital video world. The resolution and frame rates of digital video formats are more related to those of conventional video and TV formats than to those of their movie counterparts. The HD and HDTV labels also come from the world of TV, but don't really make it clear what level of image quality a device will produce.

The technical quality of digital video is influenced by a large number of factors. In addition to the resolution (i.e., number of pixels) of each individual frame and the frame rate (the number of individual frames shot per second), memory format and data compression also play a significant role in determining the quality of your results. Let's take a look at the most important factors individually.

Video Formats and Resolution

Just like analog film, digital video is comprised of a sequence of individual images or "frames". A digital camera captures these frames with an electronic image sensor and saves them in digital form. Just as different analog film formats (8mm, 16mm, 35mm etc.) produce differing image quality and maximum projection sizes, different digital video formats also produce different results.

It is not long since the first consumer-level digital cameras with built-in video modes appeared. This functionality was initially limited to shooting two-minute mini-movies with an image size of 320 × 240 pixels or less. Movie modes were at first only offered in compact cameras and didn't become available in professional-level devices for quite a while.

As technology improved, in-camera data processing speeds increased, and faster data transfer rates coupled with larger memory cards made it possible to record longer movies at higher resolutions. The latest digital cameras offer comprehensive video functionality at very high resolutions.

Today's digital video resolution far exceeds that of traditional NTSC TV pictures, which have a resolution equivalent to approximately 0.34 megapixels. High-resolution video is generally described as being "High Definition" (HD). The term HD is not precisely defined, and is used to describe resolutions of 1280 × 720 as well as 1920 × 1080 pixels. The latter format is often described as "Full HD", and is already used for many contemporary film productions. In future, all TV pictures will be broadcast in HD format. Most new TVs are capable of reproducing HD pictures,

Format	Image Width (in pixels)	Image Height (in pixels)	Aspect Ratio	Total # of Pixels	• Comments
PAL	768	576	4:3	442,368*	European TV format, half-frame transmission with 288 vertical lines*
NTSC	720	480	3:2	345,600*	American TV format, half-frame transmission with 288 vertical lines*
QVGA	320	240	4:3	76,800	Mini-movie format built into early compact digital cameras
SQ / 360p	480	360	4:3	172,800	
HQ / SD / 480p	640	480	4:3	307,200	SD = Standard Definition, a common image size in many camcorders
HQ / SD / 480p	852	480	16:9	408,960	SD = Standard Definition, a common image size in many camcorders
HD / 720p**	1280	720	16:9	921,600	AVCHD Lite format
HD / 1080i*	1920	1080	16:9	2,073,600*	• Half-frame display with 540 lines*
Full HD / 1080p**	1920	1080	16:9	2,073,600	
2K	2048	1080	>17:9	2,211,840	Professional film formats
2K	2048	1536	4:3	3,145,728	Professional film formats
4K	4096	2160	>17:9	8,847,360	Professional film formats
•* see "Interlacing" below					
•** p = Progressive Scan, see the following sections					

Common digital film formats—names and sizes

and the HD-capable digital cameras available on today's market make it easy for photo enthusiasts and professional photographers alike to shoot HD video.

The table lists the most important digital video formats and the illustrations on the next page show the physical differences between them. The detail images on pages 8 and 9 make the differences in image quality produced by different image sizes very clear.

The largest formats currently available in digital compact and DSLR cameras are equivalent to the 720p and 1080p standards.

Frame Rates and Refresh Rates

Another important video parameter is the **frame rate**, which defines the number of individual frames recorded per second (fps). The higher the frame rate, the smoother the resulting action will appear. The human eye perceives sequences of images projected at speeds of 16 fps and faster as a single movement. However, such movement only appears genuinely smooth and jerk-free at frame rates of 20 fps and more.

Cinema Projection

Movies are generally shot at 24 fps. This is a relatively low frame rate and can cause slower movements to appear jerky. Camera operators and directors circumvent this problem by avoiding the use of pans when shooting slow action.

Movie projectors use a simple trick to help film action appear smooth. The sequence of frames in a strip of film is transported through the projector at exactly the same rate it was shot (i.e., 24 fps), and a rotating shutter is used to cover the projector's light beam each time the film moves forward to the next frame, thus preventing the viewer from seeing the interruptions caused by the film's progress.

However, the human eye is especially susceptible to the differences between light and dark, and the dark phases between frames cause a strong flicker effect. In order to overcome this effect, the shutter is rotated at sufficient speed to break the light beam two (or even three) times between each frame. This means that each frame is, in fact, projected two (or three) times, resulting in a **refresh rate** of 48 or 72 Hertz (or Hz). The human eye can no longer perceive flicker at such high refresh rates.

Interlaced TV and Video Applications

A completely different technique is used to show film on a TV screen. A conventional CRT display uses a beam of electrons to project each

Full HD: 1920 × 1080 pixels

HD: 1280 × 720 pixels

HQ/SD (16:9): 852 × 480 pixels

HQ/SD (4:3): 640 × 480 pixels

PAL: 768 × 576 pixels

SQ: 480 × 360 pixels

NTSC: 720 × 480 pixels

QVGA: 320 × 240 pixels

individual film frame onto the screen line by line. This process is time-consuming, and made it impossible for early TVs to refresh each frame the way movie projectors do, causing TV films to flicker noticeably.

The scanning time for each frame had to be reduced to make higher refresh rates possible, and the solution is the so-called **interlacing** technique. This technique projects every second line of each frame onto the TV screen, using the odd-numbered lines for the first projection and the even-numbered lines for the second. This way, a refresh rate of 60 Hz (equivalent to the frequency of household alternating current) produces 60 half-frames per second instead of 30 full frames. Our eyes convert the jumps from line to line effortlessly into a whole image, resulting in a flicker-free viewing experience. We do not see the dark lines where no image information is projected because conventional CRT screens phosphoresce for a short period after each image line has been projected. The construction of the human retina, with more rods than cones at its edges, makes us more

susceptible to flicker effects at the edges of our field of view. In spite of recent technological advances, TV pictures are still broadcast as half-frames.

Interlacing is also used to shoot video, resulting in each video frame having half the height of the full image. This is why video pictures (especially where horizontal motion is involved) often appear to be covered in horizontal stripes. The individual frames covering the movement were actually shot at different points in time and are thus displayed with a slight time lag.

Full-frame or Progressive Scan Projection

Modern TFT/LCD and plasma screens address each individual pixel directly and no longer need to use interlacing techniques to produce flicker-free moving images. The entire picture is always immediately visible, just like the image created by a movie projector. This projection process is called **full-frame** or **progressive scan**. Here too, refresh rates are increased by projecting each frame twice, or by projecting interim

Digital video formats
Size comparison of the most common formats. Images as the top and on the left show old and new TV formats, while the images on the right show video camera formats.

Full HD: 1920 × 1080 pixels

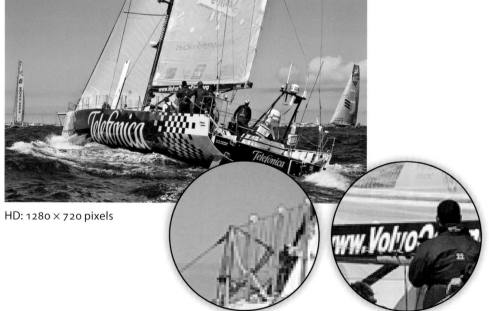

HD: 1280 × 720 pixels

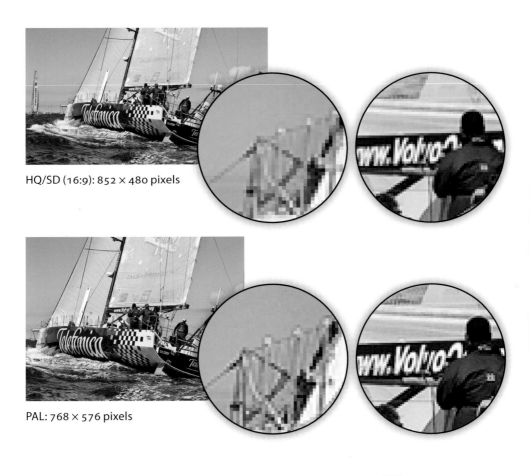

HQ/SD (16:9): 852 × 480 pixels

PAL: 768 × 576 pixels

QVGA: 320 × 240 pixels

Size comparison of digital video formats

These pages show examples of single frames for five selected
video formats. Each example also includes two details enlarged
to the same magnification. Image detail is clearly inferior for the
smaller formats.

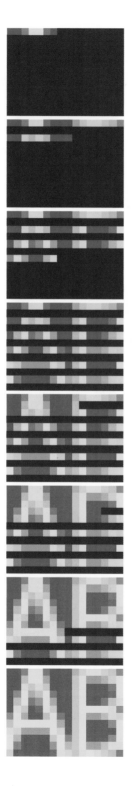

images computed using an interpolation algorithm. This way, modern TVs can achieve refresh rates of up to 200 Hz. Virtually all modern computers also use full-frame techniques to drive their displays.

General Terminology

The deeper your interest in video resolution and digital image quality, the more often you will come across the special terminology used to describe the techniques involved. Here are two examples of video nomenclature, including short explanations of what the individual terms mean:

Example #1: **720p50**
"720" describes the frame height in pixels. The entire frame has a total size (in 16:9 format) of 1280 × 720 pixels. "p" stands for "progressive scan" and "50" denotes the frame rate (here in full frames/second).

Diagram of an image being written in interlaced mode

The cathode ray starts in the top left corner of the screen and first writes the pixels for the odd-numbered lines. Once the ray reaches the bottom right corner of the screen, it writes the even-numbered lines, once again starting at top left. These two "half-frames" are usually written one after the other with a slight time lag.

Stripy interlaced image
The time lag between the writing of odd- and even-numbered lines in an interlaced image can cause stripes to appear in footage of fast-moving subjects. The individual frames in a sequence usually follow each other too quickly for this effect to be visible; the human eye only perceives the stripes when the action is paused.

Example #2: **1080i60**
"1080" describes the frame height in pixels. The entire frame has a total size of 1920 × 1080 pixels. "i" stands for "interlaced", and "60" defines the frame rate (in this case, 60 half-frames/second).

DSLR Frame Rates
Clips shot using digital compact or DSLR cameras are comprised of

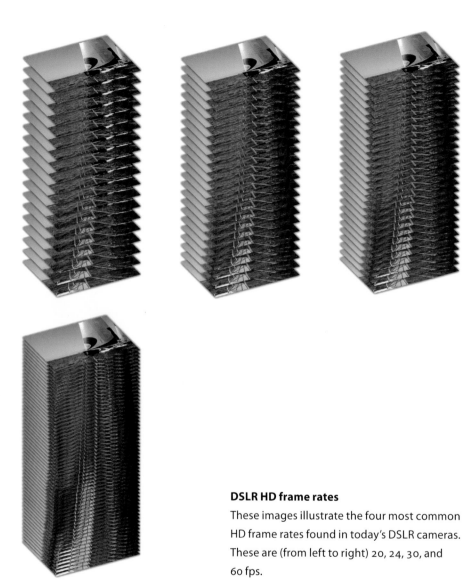

DSLR HD frame rates
These images illustrate the four most common
HD frame rates found in today's DSLR cameras.
These are (from left to right) 20, 24, 30, and
60 fps.

full-frame images, and are thus more
similar to conventional movies than
to clips shot using video cameras. The
frame rates available in most digital
still cameras currently lie between 20
and 30 fps, although some DSLRs are

capable of shooting Full HD video at
rates of up to 60 fps, making it pos-
sible to shoot slow-motion sequences
too. The difference between clips
shot at 24 and 30 fps is visible to
the human eye, and fast movements

shot at 30 fps appear much smoother. Twenty fps is simply too slow for shooting fast-moving subjects satisfactorily.

Digital frame rates are limited by technical factors, and depend mainly on the number of output channels built into the image sensor. Sensors with multiple output channels are more expensive, but can record image data more quickly by using all the available channels simultaneously. Cheaper cameras therefore usually have slower maximum frame rates. At least four output channels are necessary in order to shoot Full HD at 60 fps—a feature currently only offered in ultra-high-end DSLRs.

Some cameras limit the frame rate according to the size of the image being shot (e.g., a maximum frame rate of 20 fps for 1920 × 1080-pixel images, or 30 fps for video shot at 1280 × 720 pixels). A smaller image size is usually preferable to a lower frame rate for most subjects. A shake-free HD sequence appears more natural (and professional) than a shaky Full HD sequence.

Playback Frame Rates

Video and TV playback frame rates depend on the playback technique being used (PAL or NTSC), whereas digital video playback frame rates can be adjusted more or less at will, depending on the software you are using (QuickTime, iTunes, VLC, etc.).

It is important to select the frame rate most appropriate to your chosen playback device when processing video material. In order to achieve the best possible reproduction, you may have to change the frame rate, which will usually involve using editing software to resample the entire sequence.

Digital playback is not subject to these restrictions. If your DSLR can shoot at 30 fps, you can play your material back at 30 fps without first having to convert it to a slower rate, as is usual for video productions. Most media players automatically detect the frame rate and play recorded material back at the appropriate speed.

Data Formats and Data Compression

We have already addressed the differences between the formats and frame rates used for shooting digital video, but the data formats used for saving digital material are even more varied. Saving digital video material always involves a compromise between saving the most possible audiovisual detail while reducing the size of the resulting file to a manageable size. If video were to be saved without compression, you would very quickly fill your memory card and overstretch your camera's data transfer circuitry.

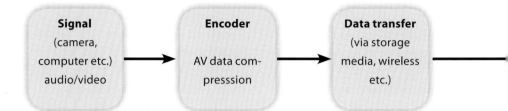

Compared to the world of digital stills photography, where only a small number of data formats (JPEG, TIFF, and RAW) are in common use, the number of formats currently available for saving conventional video material is large and sometimes confusing. Incompatibility problems make it difficult for videomakers to find the right software for processing material for playback on some devices.

Digital video is fortunately more homogenous. Camera manufacturers only use a small number of data formats, all of which are compatible with HD storage, processing, and playback standards.

Video Codecs

Video data is saved in two steps. First, a **codec** (the word stands for "encoder/decoder") is used to encode the recorded data into a specific format. Every recording device (in our case, a video-capable digital camera) has its own codec. In order to playback recorded material on a device (a computer, for example), the device

also has to support the camera's codec.

MPEG-4 and **Motion JPEG** are the codecs most often used in modern cameras and work in two completely different ways.

MPEG-4 AVC (also known as **H.264**) divides recorded video into short sequences and assumes that the contents of the frames contained in each sequence vary only slightly (except, of course, where a scene change takes place). Only the first (or key) frame of a sequence is saved as a complete image and all subsequent frames are saved in the form of motion vectors which describe the changes between consecutive frames. This process requires large amounts of computing power, but produces very small, high quality video files. This is a very "non-photographic" process, and is typical of codecs developed exclusively for video applications. MPEG-4 AVC and its cousin AVCHD are not the best editing codecs.

Motion JPEG (also known as **MJPEG**) works in a similar way to a

Decoder

AV data decompression

Receiver (Computer, TV etc.) audio/video

Schematic of a **codec (encode/decode) system**

conventional digital photo camera, saving every frame of a sequence as a compressed JPEG image. The major advantage of this technique is that every single frame can be directly addressed and processed, whereas usually only the key frames of an MPEG-4 sequence can be directly accessed. This difference is becoming less important as editing software becomes increasingly capable of processing MPEG-4 material. Motion JPEG files are usually much larger than MPEG-4 files.

Container Formats

The second step involves inserting the saved material into a so-called **AV container**. A container is used to save subsidiary information, such as audio tracks, subtitles, and menu tree data.

There are two major container formats in use in modern cameras: **Audio Video Interleave** (**AVI**) and **QuickTimeMovie** (**MOV**). AVI is an older, but more widespread format developed by Microsoft. This format

can simultaneously save multiple compressed audio and video tracks.

The QuickTimeMovie container format was developed by Apple and is extremely flexible and robust while remaining upgradable. It forms the basis of the MPEG-4 format and is a widespread standard for recording video, audio, subtitle, timecode, and chapter data for film and post-production applications.

Storage Media

In recent years, the storage media jungle has thinned out significantly, with most manufacturers using CompactFlash (CF) or Secure Digital (SD) cards for data storage. Sony is the only major camera manufacturer that still uses its own proprietary (MemoryStick) card format. Until recently, professional DSLR cameras usually used CF cards, while compact camera manufacturers tended to build SD card slots into their products. This situation is now changing in favor of a more general adoption of SD cards

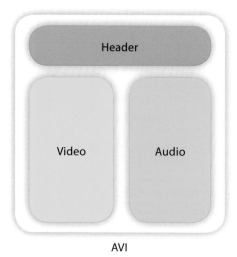
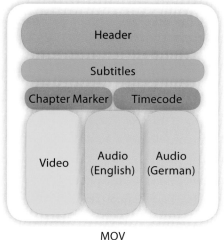

AVI MOV

Container formats

This illustration shows the two most common container
formats and the way their contents are organized

in all types of cameras. Most contemporary high-end DSLRs have a combined CF/SD slot.

Both types of card use rewriteable flash memory to store data and contain no moving parts, making them less sensitive to physical shock than conventional hard disks or CD drives.

Although all CF and SD media look the same (independent of their actual capacity), they differ widely with regard to read and write speeds. High write speeds are necessary for shooting HD video sequences, and all cameras immediately stop recording if the available memory write speed is not sufficient. Most digital cameras limit the length or size of the video files they can record. Memory card

prices increase not only with capacity, but also with higher write speeds. In order to avoid spending more than you need on storage, check your camera manual to match the maximum write speed of your memory card to that of your hardware.

The memory card or cards recommended in the camera manual are usually the best choice, and your local photo dealer should be able to help you if you need further advice.

SD Cards

There are currently three different types of SD card available, all of which have the same basic size and shape: SD, SDHC, and SDXC. The suffixes HC (High Capacity) and XC

Photos: SanDisk

Digital camera memory cards
From left to right (to scale):
CompactFlash card, SD card, MemoryStick

(Extended Capacity) indicate differences in the maximum capacity of the individual card types. Standard SD cards are available in capacities ranging from 8 MB to 2 GB. SDHC cards are available in capacities of up to 32 GB, while the SDXC specification allows capacities of up to 2 TB (terabytes). These different capacities depend not only on the size and type of the memory modules built into the card, but also on the file system the card uses to address the data saved on it. Standard SD cards use the FAT16 file system and can be read and written by any SD-compatible device. The FAT32 and exFAT file systems used by SDHC and SDXC cards can only be addressed by hardware that specifically supports the appropriate system(s). Make sure your camera and your card reader are compatible before you go out and buy the latest high-capacity cards.

In order to keep things relatively simple, all SD cards carry labels that indicate their type, capacity, and speed ratings. Confusingly, some card manufacturers use number codes as well as a megabyte per second (MB/s) figure to indicate the data transfer class of their products. The data transfer "class" of a card relates to the minimum data transfer rate the card is capable of (Class 2 > 2 MB/s, Class 4 > 4 MB/s etc.), while number codes indicate the actual read speed.

CompactFlash Cards
CompactFlash (CF) cards are also available in various flavors that are available in two different thicknesses, described as Type I (3.3 mm thick) and Type II (5 mm thick). Most newer CF cards follow the thinner, Type I specification. CF cards are available in capacities of between 1 MB and

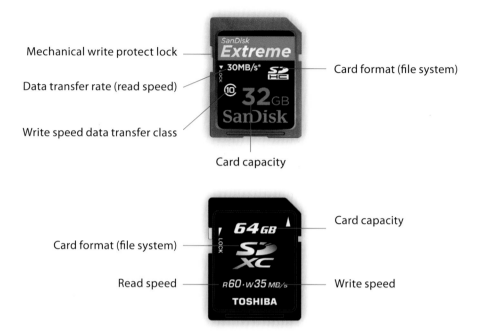

Mechanical write protect lock

Data transfer rate (read speed)

Write speed data transfer class

Card format (file system)

Card capacity

Card capacity

Card format (file system)

Read speed

Write speed

Common SD card labels

32 GB, and all cards with capacities greater than 2 GB are formatted using the FAT32 standard.

CF card performance data is not consistent, and labels such as "Pro", "Ultra", "Extreme", or "Ultimate" don't always mean the same thing. Some card manufacturers describe the read/write speeds of their products using an "×" label (for example, 166×), which describes the card's performance in relation to that of a CD. Other manufacturers simply list the data transfer rate of their products in MB/s.

Image Sensor Size

Today's video-capable digital cameras are built using a range of different-sized image sensors. The size of the sensor has a direct effect on important recording factors such as image noise and depth of field. Let's take a look at the most common sensor types.

Common DSLR Sensor Types

The smallest image sensor in current DSLR use is the **Four Thirds** type. This type of sensor has an effective surface area that measures 17.3 mm wide by 13 mm high, and has a crop

Photo: SanDisk

SD card contacts are on the back of the card and are open to the air

CompactFlash card contacts are hidden beneath perforations in the card's outer casing

factor (or focal length multiplier) of two. This means that—shooting from the same viewpoint—a 25 mm focal length lens used with a Four Thirds sensor produces the same image area as a 50mm lens used on a standard 35mm analog or full-frame digital camera.

Many camera manufacturers use APS-C format sensors with a crop factor of 1.5 or 1.6 (compared to the standard 35mm format). Examples of this type are Nikon's **DX format** sensor, which measures 23.6 × 15.8 mm and has a crop factor of 1.5, or Canon's 22.3 × 14.9 mm sensors with their 1.6 crop factor.

Professional-level DSLRs usually have **Full-frame** or **FX format** sensors. Full-frame sensors have the same surface area as a 35mm film

frame (36 mm × 24 mm). Here, the crop factor is 1.

Smaller sensors are cheaper to produce, making it possible for camera manufacturers to offer value cameras that nevertheless produce high quality images. Another advantage of a smaller sensor is that it requires comparatively small and light lenses to produce images comparable with those made using a 35mm or full-frame camera. Nowadays, the major camera manufacturers have developed complete lens ranges for their small-sensor cameras.

Smaller sensors also make it easier to produce strong telephoto effects using medium-length lenses. Ultra-wide-angle effects are more difficult to produce as they require extremely short focal length lenses which

are more difficult and expensive to manufacture.

Comparing DSLR Sensors with Common Video Formats and Video Camera Sensors

Shooting video with a DSLR becomes even more interesting when we compare the size of a DSLR's sensor with conventional movie formats or video camera sensors.

Whatever size DSLR sensor we look at, it will always be many times larger than the ones found in professional video cameras. Professional video cameras generally use sensors with a 1/2-inch or 2/3-inch diagonal, while semi-professional and hobby video cameras have sensors that are as small as 1/3-inch or even 1/6-inch. A 1/2-inch sensor with an aspect ratio of 4:3 will physically measure 6.4 × 4.8 mm, while the largest (2/3-inch) professional video sensors currently available measure 8.6 × 6.6 mm. This represents about half the length of a Four Thirds image sensor. Only the digital movie cameras that are starting to replace conventional film-based movie cameras have larger, full-frame sensors.

Sensors such as Nikon's DX type are only slightly smaller than the effective format of 35mm Academy format film frames, which measure 22 × 16 mm.

Shooting with a full-frame DSLR produces individual frames that are just as high as a 70mm *Panavision Super 70* film frame. However, the Panavision format produces frames that are, at 52 mm, significantly wider than those produced by a full-frame image sensor.

The Effects of Sensor Size on Exposure

So what differences do we encounter when shooting video using sensors that are so much larger than conventional video sensors? Let's take a look at the effect sensor size has on exposure.

If we take a standard 1280 × 720-pixel HD frame as an example, it quickly becomes clear that the individual sensor elements that record the pixels in a frame are larger in a larger sensor.

Basically, the larger a sensor element, the more photons will hit it during shooting. So, because the strength of the signal generated by a single sensor element depends on the number of photons reaching it, the signals generated by larger sensor elements don't have to be amplified as much as those generated by smaller sensor elements. The more a sensor signal is amplified, the more image noise is produced as a result, making larger image sensors less subject to noise artifacts than their smaller cousins.

In practice, this means that cameras with larger sensors produce

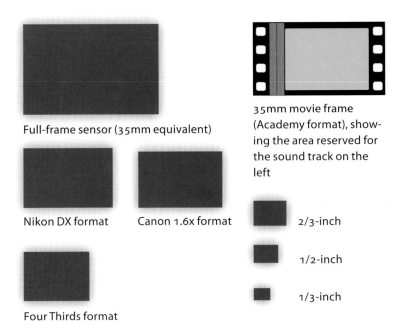

Full-frame sensor (35mm equivalent)

Nikon DX format Canon 1.6x format

Four Thirds format

35mm movie frame
(Academy format), show-
ing the area reserved for
the sound track on the
left

2/3-inch

1/2-inch

1/3-inch

Sensor sizes

This illustration shows (to scale) the differences in size between
the most common DSLR and video image sensors.
On the left are the DSLR sensors; on the right are some examples
of professional and semi-professional video camera sensors, and
a 35mm movie frame as a comparison.

better results than cameras with
smaller sensors (i.e., most video
cameras), especially when shooting
in weak light. Larger sensors also
produce less noise at higher ISO sen-
sitivity levels.

**The Effects of Sensor Size on Depth
of Field**

The large sensor in a DSLR produces
footage with much less depth of field
than that produced by a conventional

video camera, making the results
very similar in look and feel to those
produced by movie cameras. Here, it
is possible to use out-of-focus fore-
ground and background effects to
emphasize the subject or to under-
score other spatial characteristics of
a scene.

This is the main reason that the
movie modes built into many digital
cameras are not just another gim-
mick, but more of a full-blooded

revolution. Suddenly, it is possible to shoot professional-looking video on a minimal budget!

Creating movie-like results with a video camera is only possible with the help of special accessories, such as an adapter for mounting 35mm camera lenses on your video camera, or with the use of specially programmed plug-ins at the editing/processing stage. The general rule is that the depth of field of a video sequence is in inverse proportion to the size of the sensor it was shot with—in other words, a large sensor produces shallow depth of field, while a small sensor will produce footage with great depth of field. Most entry-level video cameras have very small sensors that produce footage that is sharp in every detail, from the close foreground right up to infinity.

Experience in the world of stills photography shows that wide-angle (i.e., short focal length) lenses produce images with great depth of field, while longer, telephoto lenses only allow you to keep a small portion of the scene in focus. We don't want to go into the physical and optical reasons for this phenomenon here, but it is nevertheless important to know that this is so in order to properly understand the following chapters. As already mentioned, the smaller your recording medium (film or sensor), the shorter the focal length lens necessary to capture a scene. Compact digital camera manufacturers often state the focal lengths of their lenses in terms of the more common 35mm format in order to make it easier for the photographer to judge lens performance.

Let's look at an example: if you are filming a person at a distance of 2 meters using a 35mm-format camera, a 50mm lens is ideal for capturing the entire subject. If you use a medium aperture (f/4, for example), the depth of field for a 50mm lens will extend from around 14 cm in front of the subject to about 17 cm behind it. The further away from the

Creating a movie-like effect by reducing depth of field
A larger image sensor (used to shoot the lower image) requires a longer focal length lens to capture the same scene as a shorter lens used with a smaller sensor (as in the upper image). The shallower depth of field caused by the longer focal length lens in the second image causes the background to blur, bringing the subject into sharp relief. This movie-like effect is difficult to achieve using conventional video cameras.

plane of focus you look (both in front of and behind the subject), the more blurred image detail will be.

Shooting the same scene with a professional video camera with a 1/2-inch sensor requires a lens with a focal length of approximately 9 mm (the crop factor is here approximately 5.6). Focused at a distance of 2 meters, such a lens will produce a field of focus that stretches from between 1.1 and 8.9 meters from the camera. This makes it difficult to deliberately shoot details that are not very close to the camera out of focus. Even with a high-grade lens opened up to its maximum aperture of f/1.8, a professional video camera will capture all detail in a range from about 1.6 meters in front of the subject to about 2.8 meters behind it. Here, details in the far background will be blurred, but the overall effect is still not comparable to that of a 35mm camera. Remember, the sensors in most semi-professional video cameras are even smaller than the one we used in our example.

A small sensor can, however, also be an advantage, especially when it comes to shooting macro footage. The closer the field of focus is to the camera, the shallower the depth of field will be, making large sensors (with their inherently shallow depth of field) less useful for close-up work. A full-frame camera with a 60mm macro lens used to shoot a subject at around 30 cm from the camera will produce a depth of field (at f/8) of less than 1 cm! This means that the subject will become blurred the moment it moves more than 1 cm towards or away from the camera. The professional video camera in our example above requires a lens with a focal length of about 11mm to shoot the same subject at the same distance, and will produce a field of focus that stretches from 7 cm in front of the subject to about 13 cm behind it, giving us a much greater margin for error should the subject move from its original position.

There are many depth-of-field calculators available on the Internet or built into editing software packages, but please note that—due to differing definitions of the size of circles of confusion—the results often differ for same-sized sensors.

Types of Sensors

The development of real-time **Live View** functionality led to the idea that a stills camera could be used to record moving images. Simply put, video recorded using a DSLR is nothing more than a Live View sequence recorded onto a memory card.

It might appear unimportant to know exactly what type of sensor is built into your camera, as long as it does its job of recording images and

Sensor size	Focal length	Aperture	Subject distance	Closest focus distance	Furthest focus distance	Extent of resulting field of focus
Full-frame	52 mm	f/4	2 m	1.85 m	2.18 m	0.33 m
DX or APS-C	35 mm	f/4	2 m	1.78 m	2.28 m	0.49 m
Four Thirds	26 mm	f/4	2 m	1.70 m	2.42 m	0.72 m
1/2-inch	9.2 mm	f/4	2 m	1.14 m	8.09 m	6.95 m
1/2-inch	9.2 mm	f/1.4 *	2 m	1.58 m	2.73 m	1.15 m
Full-frame	52 mm	f/32 **	2 m	1.20 m	5.96 m	4.75 m

* closing a (1/2-inch sensor) video camera's aperture right down to f/1.4 results in a depth of field that is still greater than that produced by a DSLR
** a full-frame video DSLR still has shallower depth of field than a video camera, even at f/32

Sensor size and depth of field
The table lists the depths of field that are present for a consistent angle of view and aperture, as well the apertures required to adjust the available depth of field.

video. In spite of the unbelievable speed and accuracy of modern image sensors, it is important to remember that a video DSLR is still first and foremost a stills camera. The sensors built into such cameras are designed to produce optimal photographic results, especially with respect to sharpness, color quality, sensitivity, and noise reduction.

CCD and **CMOS** are the two basic types of sensor used in modern digital cameras. Both types are very highly developed, but each still has its own advantages and disadvantages. CMOS sensors generally use less power than CCD sensors, and

DSLR camera with APS-C sensor

Shot at f/4

Shot at f/5.6

Shot at /f8

Shot at f/11

Shot at f/16

Depth of field in relation to sensor size

The images on the left were recorded using a camera with an APS-C sensor, while the images on the right were recorded using a compact camera with a sensor of the size found in a 2/3-inch professional video camera. The greater depth of field produced by the smaller sensor is obvious, even at large apertures (f/11 with an APS-C sensor is equivalent to approximately f/2.8 for the compact).

Compact camera with 2/3-inch sensor

Shot at f/2.8

Shot at f/4

Depth of field in relation to aperture
Here is another example of the reduced depth of field caused
by larger apertures. The image was shot using an APS-C DSLR
stopped down to f/1.8.

produce less heat and image noise. Output from CMOS sensors can also be recorded more quickly, making them the sensor of choice for many high-speed, professional-level cameras.

Rolling Shutter Effect

One of the major differences between CCD and CMOS sensors is the way the charge state of the sensor elements is read and stored while the shutter is open in Live View mode. When shooting stills, a mechanical shutter cuts off the stream of photons hitting the sensor at the end of the exposure, thus preventing the individual sensor elements

from becoming overloaded. During video shoots, the charge produced in the sensor elements has to be continually transported away from the sensor and recorded. CCD sensors read and store each individual frame before the next frame is recorded, whereas CMOS sensors read image information line by line using a **rolling shutter**, which makes lines that have already been read available for recording new information. This technique can cause the so-called **rolling shutter effect** for fast-moving subjects or if the camera is moved too quickly during shooting.

If the camera is panned too quickly, or if a subject moves rapidly from one

Shallow depth of field in macro situations

The shallow depth of field inherent in DSLR macro lenses is a disadvantage when filming close-up subjects. The field of focus is extremely small, making it virtually impossible to adjust close focus accurately for moving subjects. Shooting moving subjects close-up is much easier with a video camera's mini-sensor!

The rolling shutter effect

These images of a moving train were taken at a 0.6 second interval and show the rolling shutter effect typical in cameras with CMOS sensors. The close range and the acute shooting angle mean that the part of the train nearer the camera is moving through the frame faster than the more distant parts. The train door is skewed in the upper image, but not in the lower image, where it is further from the camera. The windows entering the frame appear skewed in the lower image.

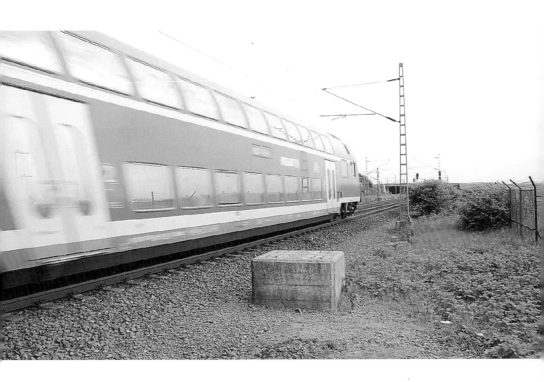

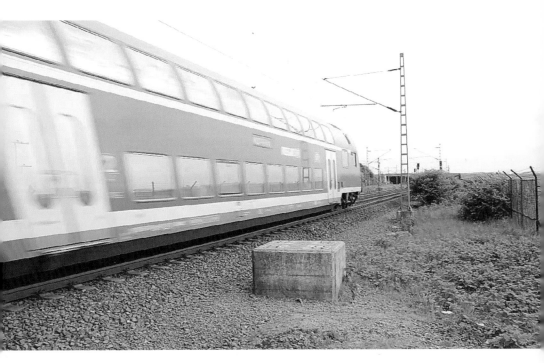

side of the frame to the other, diagonal distortion (or **skew**) can result. This is because the subject moves faster than the time it takes to read the image information line by line from the CMOS sensor. The earlier image lines show a different subject state than the later lines.

The term "rolling shutter effect" originated in the analog photography world and is based on the effect produced by vertical focal plane shutters used to photograph fast-moving subjects. This effect can also affect stills shot using CMOS sensor-based cameras; for example, helicopter rotor blades shot using a CMOS sensor often appear warped or bent.

The rolling shutter effect not only affects video DSLRs. Professional-level video cameras are usually equipped with CMOS sensors, and are also subject to rolling shutter effects. The only real solution to this problem is to avoid quick pans and fast motion. Some video camera manufacturers are starting to use sensors that record images column by column instead of line by line. This means that rolling shutter effects only occur for subjects that move vertically or for vertical pans—situations that occur only rarely under normal circumstances.

Blooming

The rolling shutter problem that is (unfortunately) fundamental to CMOS sensors also has its counterpart in the **blooming** effect common to CCD sensors. This effect occurs when a CCD is subjected to overexposure, and produces a "white hole" in the image accompanied by vertical or horizontal white lines. A typical blooming situation occurs when the camera is panned toward the evening sun—the moment the bright sun enters the frame, the sun appears enlarged and produces distracting vertical stripes that extend to the top and bottom edges of the frame.

Optimum Use of Image Sensors

As long as you are aware of the weaknesses of your system (CMOS or CCD), you will quickly learn to avoid situations in which these weaknesses affect your results.

The perfect camera has yet to be created, but many astonishing films and photos prove that it is possible to achieve spectacular results in spite of the technical shortcomings of the equipment available. Pans into bright light can be avoided by using a short lens to adjust framing, or simply by tilting the camera. You can also reduce the negative effects of fast-moving subjects by adjusting your viewpoint or framing.

Blooming

Here, a blooming effect has spoiled our attempt to use video mode to capture a wonderful panorama view. The camera's CCD sensor produces vertical stripes through the entire image as soon as the sun enters the frame.

Blooming comparison for CCD and CMOS sensors

Here, we used two different cameras to simultaneously perform the same pan—with obvious results. The upper image was shot using a camera with a CCD sensor, and shows significant blooming. The lower image was shot using a CMOS-based camera and shows no blooming at all.

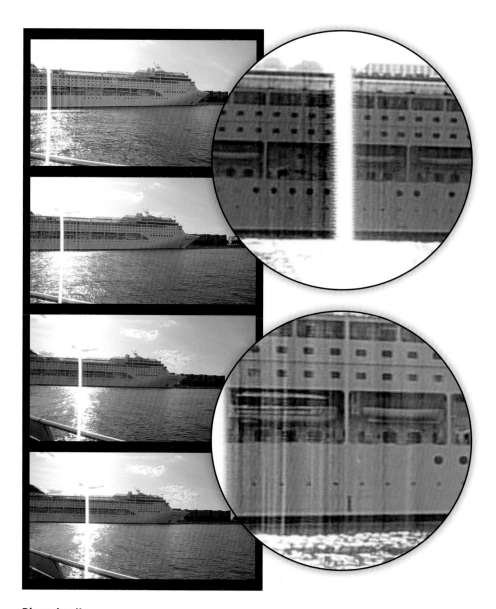

Blooming II

This backlit sequence—shot using a CCD-based camera—shows
how blooming effects can also produce multiple colored stripes
that affect large parts of the image area. The resulting artifacts are
especially obvious in the enlargements.

Blooming effects under artificial light

Blooming effects can become even more accentuated in
artificial light. Here, pulsing purple stripes move across the
entire frame.

Equipment

by Helmut Kraus

Clip: Eib Eibelshäuser

A camera is, of course, your most important piece of equipment if you want to shoot video. But, in practice, you need more than just a camera and lens to achieve great results. Additional lenses, lighting gear, tripods, and much more besides make shooting easier, or even possible in the first place. This chapter aims to give an overview of the more essential and useful gear currently available.

Types of Cameras

Although this book mainly covers shooting video using DSLRs, we will also discuss the characteristics of other types of HD-video-capable digital camera. Every camera concept has its own particular advantages and disadvantages, but the photographic features of a camera will probably still influence your purchase decision most. If you find DSLRs too heavy or complicated, you probably won't buy a DSLR just for its excellent video features. By the same token, if you feel you only need a single lens (for example, a 10× zoom), a bridge camera will probably suit your needs better than a more expensive DSLR. Experienced DSLR photographers who want to experiment with video, but whose cameras do not have built-in video features, will probably start by trying out a video-capable compact before deciding whether to upgrade their

entire setup. The following overview will help you decide which type of camera is right for you.

Compact Cameras

The major advantage of compact cameras is their small size. The compact segment includes a wide range of camera types, from fully automatic to fully manual, with lenses that range from a single, fixed focal length to 10× or 12× superzooms. The range of prices is also enormous—the latest compact can cost as much as a modest DSLR kit, while last year's models go for as little as the cost of a memory card a couple of years back.

With only a few exceptions, all compacts have very small image sensors, making the video they produce very similar in look and feel to that produced by conventional camcorders. Most compacts also have fixed lenses, which seriously reduces their creative potential.

Bridge Cameras

Bridge cameras generally have longer, brighter zooms than compacts, and the range of built-in features is often more similar to those found in DSLRs. Nevertheless, their small sensors and fixed lenses often make them no better for shooting video than their compact counterparts.

Common types of camera
Clockwise from left to right are a DSLR, a compact digital,
and a bridge camera, shown comparatively to scale

Digital Single Lens Reflex (DSLR) Cameras

Video functionality has only recently become available in DSLR cameras, but is sure to become a standard feature in future models in both the professional and hobby segments.

The two main advantages when shooting video using a DSLR are the large sensor and the interchangeable lens capability. A DSLR is the best alternative to a "real" movie camera for shooting high quality video, and that at a fraction of the cost.

Lenses

Lenses are the most important creative element of a film or photo setup, and shooting video using a DSLR allows you to select the best lens for every situation. Although all photo lenses can be used to shoot video, some are better suited to the job than others.

Before we summarize lens types and their suitability for various applications, we will look at a few basic factors governing the choice of lens when shooting video.

The **focus ring** should be easy to operate. Many cameras do not allow

Camera type	Advantages	Disadvantages
Compact	• Small size—can be transported and used anywhere • Large choice of different HD-capable models	• Small image sensor, resulting in video "look". Movie "look" not possible. • Lenses not interchangeable • Lenses often have small maximum aperture
Bridge camera	• Large zoom range and large maximum aperture	• Small image sensor, resulting in video "look". Movie "look" not possible. • Lenses not interchangeable
DSLR	• Large image sensors enable movie "look" • Large range of bright lenses available • Lens range greater than that available for video cameras • Very high image quality • High sensor sensitivity makes effective shooting in low light possible	• Comparatively high purchase price • Large size

Camera types: advantages and disadvantages

autofocus in video mode, so manual focusing is much easier if the focus ring is easy to distinguish from the aperture and zoom controls. Focus errors are much more critical when shooting video clips than when you are shooting photos.

Varifocal lenses are zoom lenses whose focus settings change with the zoom setting and are not very useful in a video context, especially when autofocus is not available. It is extremely difficult to zoom and focus simultaneously while keeping an eye on all your other settings. As varifocus is not a significant factor in a photo context, it is often difficult to tell from the accompanying technical data whether a lens is varifocal or not. Varifocal lenses can often be identified by the focus markings on their barrels that relate to differing focal lengths, but the surest way to

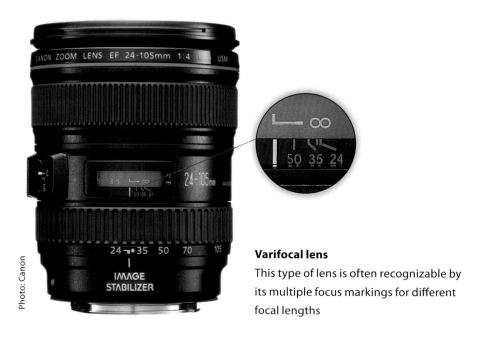

Photo: Canon

Varifocal lens
This type of lens is often recognizable by its multiple focus markings for different focal lengths

find out is simply to try out the lens in question.

Your lens should have an easily readable **focusing scale** to help you turn the lens barrel in the right direction while familiarizing yourself with the camera. There is no industry standard for focusing scales, and the two largest Japanese camera manufacturers happen to use focusing scales that run in opposite directions!

A focusing scale also helps to find the critical point of focus in a scene. For example, if a scene involves an approaching person who is supposed to stop 3 meters in front of the camera, the focusing scale will help you direct the action, even if it is not clear

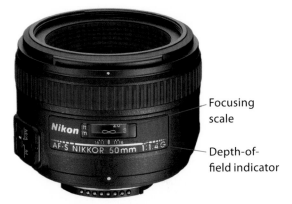

Focusing scale

Depth-of-field indicator

Non-suitable lens
This lens has neither a focusing scale nor a depth-of-field indicator

Suitable lens
This lens has both a focusing scale and a depth-of-field indicator

through the viewfinder whether the subject has reached the appropriate point or not.

The lens should ideally have a physical stop at infinity. This simplifies use of the camera, especially for landscape scenes, where you simply have to rotate the lens to its furthest point to obtain ideal focus. If a lens can be focused beyond infinity, you can easily end up with out-of-focus footage. Unfortunately, most autofocus lenses can be rotated beyond infinity—but maybe that's a good excuse to dig out and try your old, manual focus lenses for a video shoot.

A **depth-of-field indicator** is also a very useful feature, and saves having to use impractical printed or online depth-of-field tables.

Wide-angle Lenses

The availability of high quality wide-angle and ultra-wide-angle lenses is a very good reason for shooting video with a DSLR. Wide-angle lenses have never played a significant role in shooting conventional film and video, making a video scene shot with a 21mm, a 24mm or a 28mm lens a refreshing view for many subjects. The wide-angle end of the zoom range built into consumer-level camcorders is generally limited to around 36mm (35mm equivalent), making it virtually impossible to create a truly wide-angle feel.

Wide-angle lenses have an inherently large depth of field due to their low reproduction ratios, so a large maximum aperture is important if you want to retain a movie-like look

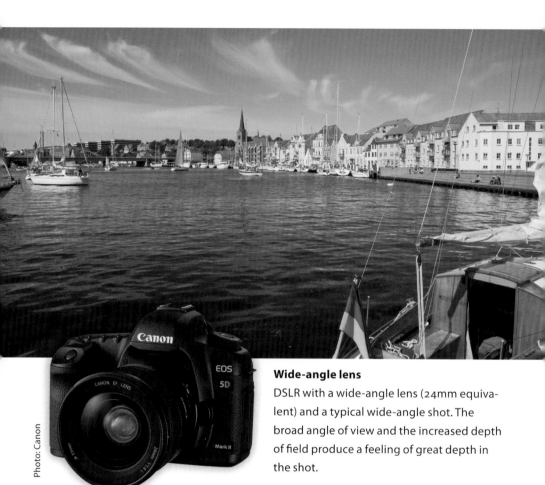

Photo: Canon

Wide-angle lens

DSLR with a wide-angle lens (24mm equivalent) and a typical wide-angle shot. The broad angle of view and the increased depth of field produce a feeling of great depth in the shot.

in your wide-angle shots. You can increase the drama in a wide-angle shot by shooting close foreground detail in sharp focus in front of extremely distant-looking background detail.

Wide-angle lenses are not, however, just good for producing stylish effects, but are often indispensable tools when you are shooting in confined spaces or at very close range.

Standard Lenses

Standard photo lenses also make good standard video lenses, and cover a field of view very similar to that of the human eye. Scenes shot with standard lenses appear very natural. The perspective produced by standard lenses is neither over-the-top like a wide-angle perspective, nor obviously condensed like that produced by telephoto lenses.

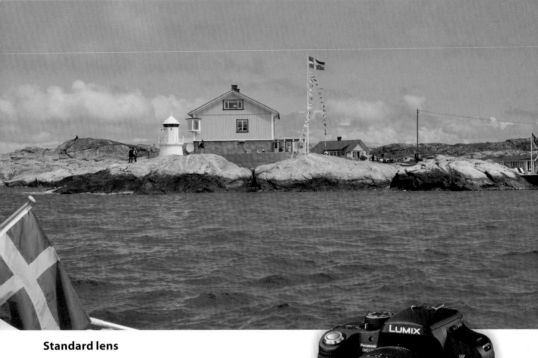

Photo: Panasonic

Standard lens

DSLR with a standard lens (50mm equiva-
lent) and a typical standard focal length
shot. The angle of view is largely equivalent
to that of the human eye and appears clean
and natural.

Tips & Tricks

Even if one of your zoom lenses
covers standard focal lengths, it
is still often worth purchasing a
bright standard lens. Standard
lenses with large maximum aper-
tures of f/1.4 or f/1.8 are inexpen-
sive and are a good way to get
started in the exciting world of
available light photography.

Telephoto Lenses

Long focal length lenses are just
as indispensable when shooting
video as they are when shooting
stills. Telephoto lenses are used to
condense a scene and to make the
distances between individual objects
appear smaller. Two people standing
behind one another five meters apart
will appear much closer together
through a telephoto lens, but much

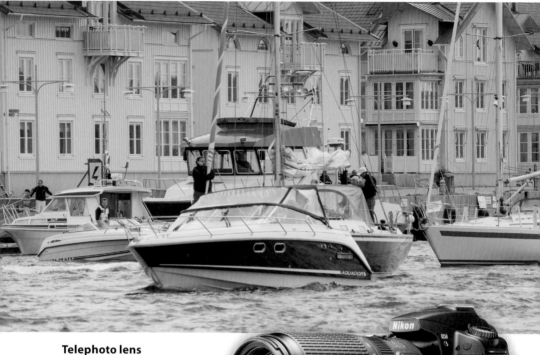

Telephoto lens
DSLR with a telezoom lens (330mm equivalent) and a typical telephoto scene. The small angle of view makes the objects appear closer to one another than they really are.

Photo: Nikon

further apart than they actually are when viewed through a wide-angle lens. This effect can be very useful, especially when filming action shots. Have you ever noticed how movie action is often shot using long lenses, making the actors appear much nearer to the (often explosive) action?

Zooms and Superzooms

Zoom lenses are very popular, as they make it possible to reduce the overall size of a camera kit while retaining a wide range of focal lengths. Purists nevertheless tend to avoid using zoom lenses because they often produce images of lower quality than fixed focal length lenses of the same brightness. Distortion and chromatic

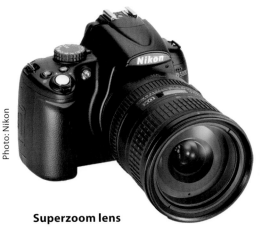

Superzoom lens

DSLR with an 11× superzoom attached. The images on the right are taken from a zoom covering the entire range covered by the lens (28 to 200mm equivalent).

aberration are the main problems common to nearly all superzooms, and are artifacts that are not (yet) easy to correct.

The purists, however, don't seem to bother lens manufacturers, and recent years have seen an explosion in the number of zooms and super-zooms (with a zoom range of 5× and more) on the market. Some modern zooms are actually better than many of their older fixed focal length coun-terparts, but zoom lenses still gener-ally suffer from small maximum aper-tures, and even large image sensors do not wholly compensate for this.

Whatever qualitative disadvan-tages zoom lenses may have, they are still capable of zooming—an

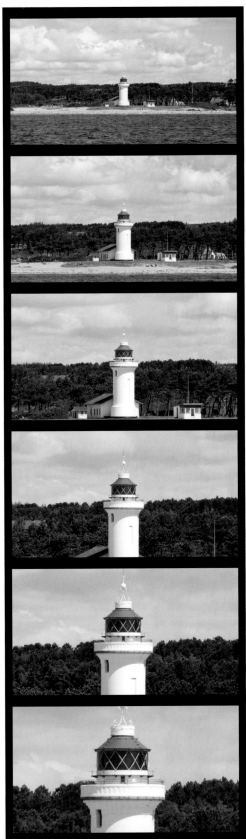

DSLR fitted with a **macro lens**

important creative element in many film scenes. A zoom can quickly attract the viewer's attention to a specific detail in a scene and zooming out to an overall view can just as quickly provide important context information. Zooming from a single standpoint can also be used to replace tracking shots, and doesn't require cumbersome dollies or steadycams.

Ultra-bright Lenses

The maximum aperture is probably the only characteristic of a lens that cannot be compensated for using technology. The zoom lenses built into most camcorders cannot really be described as bright, making a DSLR with a bright lens a serious contender when it comes to producing a movie-like look in a video sequence.

Even the brightest lenses gain depth of field with decreasing aperture, and shooting at f/8 will produce the same result whether your lens has a maximum aperture of f/1.4 or f/5.6.

Brighter lenses also allow you to use lower ISO values when shooting in low light, thus helping to keep image noise to a minimum.

Ultra-bright lenses usually have fixed focal lengths, and their major disadvantages are price and weight. Even if your budget allows, you still need to decide if you really need the extra brightness and whether your planned location is suitable for the use of heavy gear. If you need a lightweight setup, bright lenses are generally taboo, as the weight of a lens increases disproportionately to the increase in focal length. A bright standard lens can weigh twice as much as a normal standard lens, and the difference is usually even greater for bright telephoto lenses.

Macro Lenses

Macro lenses are an essential part of every serious photographer's kit, but are less important in a video context. Simply attaching a macro lens to your camera is not a complete solution and you will need additional gear (such as a special macro tripod) to keep your pans and zooms steady.

Macro lenses can, however, still be used to produce effective video sequences with unusual special

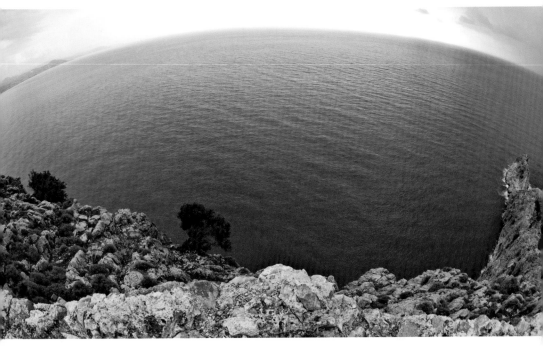

Full-frame fisheye shot
Showing typical spherical distortion

effects such as a focus pull from extreme close-up right out to infinity.

Fisheye Lenses
Fisheye lenses are ultra-wide-angle lenses characterized by the severe spherical distortion they produce. They cover extremely wide angles of view of up to 180 degrees. There are two basic types of fisheye lens that produce either full-frame or circular images. Circular-image fisheyes are not particularly suited to shooting video, but do create a very unusual effect for occasional use. Full-frame fisheyes can be used to produce extremely wide format images that, as the name suggests, cover the entire frame.

Photographers tend to either love or hate fisheye effects, but the video world has yet to decide. Fisheye views in a video context were extremely rare until video-capable DSLRs hit the market, but can now be used to produce a range of hitherto unknown effects. Shooting in extremely cramped spaces is only really possible using ultra-wide-angle or fisheye lenses, and the distortion these

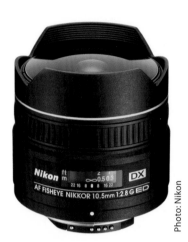

Photo: Nikon

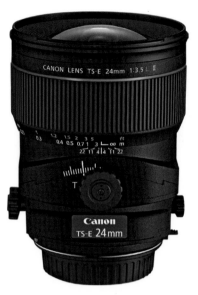

Photo: Canon

Fisheye lens

These lenses have extremely short focal lengths and angles of view of up to 180 degrees

Tilt/Shift Lens

The optical axis can be shifted vertically or horizontally, and the plane of focus can be tilted using the built-in control wheels

lenses produce always adds drama to a scene.

Tilt/Shift Lenses

Tilt and shift lenses are basically unknown in the movie world, but their special functionality can still be used when shooting video.

The shift function allows you to move the optical axis of the lens either vertically or horizontally in relation to the image sensor. This function can be used, for example, to shoot a mirror head-on without the camera itself appearing in the

shot. Shift lenses can also be used to effectively eradicate converging lines. If you are shooting a tall building, instead of having to tip the camera, a shift lens allows you to keep the camera horizontal while framing the entire building in your shot.

Tilt lenses make it possible to tilt the plane of focus of your lens by changing the orientation of the lens plane. Normally, the image plane, the lens plane, and the plane of focus are parallel to one another, and produce a sharp image on a plane that is parallel to the image sensor. If the lens

Photo: Monochrom

Photo: Lensbaby Inc.

Subjektiv
The Subjektiv allows you to create videos with a nostalgic, old-fashioned look

Lensbaby
The Lensbaby is a special close-up lens, and is available for all common DSLR lens bayonets. Focus and positioning of the plane of focus are set by bending the flexible lens barrel

is tilted, it produces a sharp image plane that intersects with the lens plane and the sensor plane. A typical tilt effect is to tilt the plane of focus parallel to the floor, producing an image that is sharp from the near foreground right up to infinity. Such tricks can also be effectively applied to video sequences.

Exotic Lenses
Camera manufacturers and third-party companies offer almost endless lens variations for most camera models, and special adapters allow you to mount lenses that weren't specifically designed to fit your camera.

As well as modern lenses, you can use adapters to mount interesting historical lenses on your camera. Older lenses can often be purchased quite cheaply from photo dealers or on eBay.

However, some modern lenses are particularly interesting for shooting video, and I would like to recommend two of them here.

The first of these is the **Subjektiv** manufactured by Monochrom (www. monochrom.com). This is not so much a lens as a lens construction kit that ranges from a simple pinhole adapter to a multi-element achromatic lens. This lens is the first to enable you to shoot video through a

Lens type	Advantages for video use	Disadvantages for video use
Wide-angle	• Short focal lengths provide wider angles of view than are normal for video cameras • Unusual view of the subject • Shooting also possible under cramped conditions	
Standard	• Standard focal length for shooting video • Natural-looking images	
Telephoto	• Allow shooting of distant objects • Increased drama through optically reduced distances between objects	• Tripod essential • Blue casts, mist, and mirage effects accentuated
Zoom and Superzoom	• Large range of focal lengths without having to change lenses • Lenses interchangeable if necessary • Zoom during shooting possible—helps to guide viewer's attention • Zooming can be used instead of dolly shots	• Comparatively small apertures • Tripod essential for longer lenses • Lower image quality (chromatic aberrations, distortion) compared to fixed focal length lenses
Ultra-bright	• Very shallow depth of field with aperture wide open • Ideal for reproducing a movie-like look • Can be used with low ISO values in low light situations	• Expensive • Heavy, difficult to transport • Price and weight increase exponentially with focal length
Macro	• Unusual video viewpoint	• Shallow depth of field problematic for moving subjects • Can only be used with specialized, damped tripods

Lens type	Advantages for video use	Disadvantages for video use
Fisheye	• Very unusual shooting perspective—not previously available • Shooting also possible in extremely cramped situations	• Circular fisheye images not suitable for video aplications
Tilt/Shift	• Optical axis can be shifted • Prevents converging lines • User-controllable positioning of the plane of focus	

Lens types: advantages and disadvantages in various situations

pinhole using a DLSR. Those of you experienced in the use of pinhole stills cameras will know that this presents pretty amazing technical possibilities.

Video sequences shot through a pinhole aperture have a peculiar, quasi-blurred appearance. Once processed using black-and-white or color filters, pinhole footage produces moving images of a completely new nature.

My second tip is the **Lensbaby**. Lensbabys are special macro lenses with a built-in tilt function that allows you to tip the optical elements of the lens in relation to the film plane. A Lensbaby mounted on a DSLR allows you to shoot spectacular close-ups that are simply not possible using any other lens.

Using Video Lights and Reflectors

The allure of film and photography lies in the ability to capture a moment and to save it exactly as it happened in a photo or a video, and shooting in available light is a sure-fire way of keeping a scene authentic. It is nevertheless often necessary to supplement available light with artificial light or to manipulate it using reflectors.

Everyone who has ever spent time on a film set will know how bright it is there. Most film situations—whether in advertising, corporate, or music videos—require the use of large numbers of spots, reflectors, and other lighting gear to properly set the scene. Under such circumstances, all involved are familiar with

Photos: Lastolite/Bogen imaging

Photo: Sachtler

Reflectors

Reflectors are constructed of reflective material and are nearly always foldable. They are used either handheld or attached to stands to brighten the subject with reflected natural light. The reflected light can be hard or diffuse, depending on the surface material used. Colored reflectors are also available and are useful for producing warmer hues.

LED video lights

LED video lights produce much less heat and use much less power than conventional movie lights. They are available in daylight and tungsten versions, and are powered either using rechargeable batteries, an AC adapter, or a car battery adapter.

the technical necessities of shooting film and the extra light doesn't bother anyone. Things are, however, very different in a documentary setting. Everyone involved should (for legal reasons) be aware that they are being filmed, and "everyday folks" who are not used to such situations are often unsettled by bright video lights.

Shooting video with a DSLR reduces the necessity for using additional, artificial light to a minimum. Today's highly sensitive image sensors and bright lenses make shooting video in available light easier than ever before, and even night scenes can be shot professionally without using extra tricks or post-processing. The use of special lens filters to simulate darkness in broad daylight has

been consigned to the history books by modern video DSLRs.

Artificial light should only ever be used where it is absolutely necessary. **Reflectors** are much easier to use than **video lights**, if only because they don't require electrical power to operate. Additionally, technological progress has helped to develop compact, battery-powered LED video lights that, together with high-sensitivity image sensors, provide perfectly adequate lighting for most situations.

Tripods

A tripod is an important accessory when shooting stills, and is all but indispensable when shooting video. Photo and video tripods are markedly different, and most of the major differences relate to the tripod head. Photo and video tripods need to strike the best possible compromise between stability and portability. A good photo tripod is, however, not necessarily suited to video use, while just about every good quality video tripod can also be used in a photographic setting. The only limitation here is that video tripod heads are not usually designed to be tilted through 90 degrees for portrait-format shots, due to the simple fact that there is no such thing as a portrait-format video.

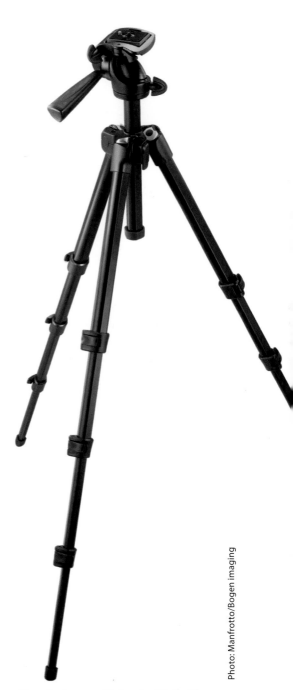

Photo: Manfrotto/Bogen imaging

Simple, low-end tripod with fluid-damped video head

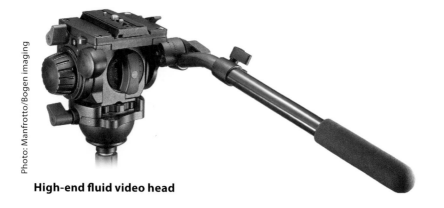

Photo: Manfrotto/Bogen imaging

High-end fluid video head

Photo: VariZoom

Steadycam
Steadycams are designed so that camera shake is absorbed by the user's body, making handheld pans and dolly-shots possible

The most obvious difference between photo and video tripod systems is the type of damping system used for the major movements. A photo tripod is only moved between shots and requires no special damping mechanism for pan or tilt movements, whereas a video tripod head is moved during shooting, making it necessary to keep all pans and tilts as shake-free as possible. High quality video heads are therefore equipped with fluid damping or epicyclic gearing systems that make it possible to begin and end all camera movements quickly and smoothly.

In addition to conventional tripod/head combos, there are also a number of alternative camera supports available, including tripods that can be fixed to a vehicle using suction cups and beanbags in many different shapes and sizes.

A steadycam is a more complex video camera support. This type

GorillaPod

The novel, flexible GorillaPod is available in several sizes and can be stood on or fixed to a wide range of surfaces and objects

Beanbag

Beanbags form a simple, stable camera support on uneven surfaces

of system uses the natural shock-absorbing characteristics of the human body to allow you to perform virtually shake-free handheld pans and dolly shots.

The ultimate camera support is a crane and jib system, which allows simultaneous horizontal, vertical, and rotational movements. These systems are available in motorized versions and can be programmed to precisely duplicate particular camera movements—a function that is particularly useful when it comes to merging film material with computer animations at the post-processing stage.

In spite of the huge range of fascinating tripod technology available on the market, it can also be an interesting challenge to shoot handheld. Handheld video often has an authentic feel, and it is nowadays possible to perform acceptable handheld pans with the help of image-stabilized lenses. Remember, it is also possible to use software tools to stabilize shaky footage during post-processing.

Foto: Nikon

Built-in microphone

The built-in microphone in most video-capable DSLRs is positioned inconspicuously on the front of the camera body, and is recognizable by the mesh pattern of small holes covering it

Accessory microphone socket

Some DSLRs have a connector for third-party accessory microphones

Using Microphones

The microphones built into most video cameras are not really suited to the job, so if you intend to shoot DSLR video with location sound you will need to acquire an accessory microphone. Make sure your camera has an appropriate microphone socket before going ahead with a purchase. Without a good, external microphone, you will quickly give up experimenting with sound.

The major disadvantage of most built-in microphones is that they record not only external sounds, but also the sounds generated by the camera's internal mechanisms, including its autofocus and image stabilizer motors. Built-in microphones are often poorly insulated against wind and other atmospheric disturbances, which quickly leads to poor sounding results. We can only hope that future cameras will be better equipped.

You can also use a separate sound recording device instead of a microphone.

Spirit levels
Simple, 2D, and 3D
models

Other Useful Gadgets

The little things are sometimes the most important, and every photographer and video-maker has his or her favorite accessories for making life easier, especially on the road. Listed here are a few of the indispensable but inexpensive (or even free) bits and pieces that every camera enthusiast would sorely miss if they weren't around.

Spirit Level
Spirit levels are useful for precise horizontal or vertical camera positioning—important when you need to reproduce a neutral perspective or to avoid converging lines in your shot.

There are various models available, each with its own particular advantages and disadvantages. Many older cameras and most quality tripods have a simple level built in. You can also purchase two- or three-dimensional spirit levels and there are nowadays even digital models available that indicate correct levelling using LEDs.

Some cameras are equipped with gyroscopic sensors, making it possible for the camera to automatically detect whether images were shot in panorama or portrait format. Some of the latest models detect whether the lens axis is level and can also project an artificial horizon onto the camera's monitor. Such features will probably become standard in future camera model generations.

Lens Cloth
Special cloths are indispensable for keeping your gear—especially your lens—dust free. Ideally, you should carry several different grades of cloth for various purposes, but in an emergency it is better to use a Kleenex or your T-shirt to remove dirt or water droplets rather than risk spoiling your shot.

A good mix is to carry a few disposable cloths for removing fingerprints and other dirt, and to keep a microfiber cloth handy for finer cleaning.

Blower Brush
A simple blower brush is a useful cleaning tool and has the added advantage of non-contact operation.

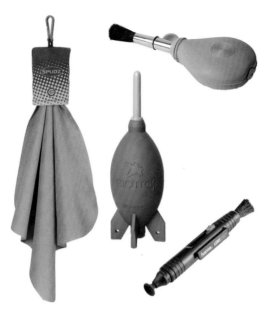

Essential camera cleaning tools
A lens cloth (here with a built-in carrying pouch),
a blower, a dust brush, and a blower brush

Tips & Tricks

Optical equipment should be
cleaned as often as necessary but
as infrequently as possible. Every
time you clean your lens, you risk
damaging it, so take great care
when cleaning your gear. Mod-
ern lens coatings are specially
hardened, but are nevertheless
not resistant to sand and grit if it
is unintentionally rubbed into a
lens element. Always attempt to
remove dirt by blowing it off your-
self or using a blower brush before
you resort to physical cleaning
with a cloth.

This is especially useful for removing
dust from your focusing screen with-
out risking damage to the camera
mirror.

Grayscale and Color Control Cards

Grayscale and color control cards are
handy for video-makers as well as
photographers.

These cards are used to take test
shots of a scene which can then be
used as a reference when making sub-
sequent corrections to exposure and/
or color balance. The card contains
various easily reproducible color and
tonal values, and if you correct your

values so that the values shown on
the card look right, the rest of the
shot will be automatically correctly
exposed. Make sure the card is placed
where it is evenly and properly lit.
If the card is shaded or is located in
bright light, you will not be able to
use the resulting test shots to pro-
duce good overall results.

Light Meters

Many experienced photographers
rely on their camera's sophisticated
built-in light and exposure meter-
ing systems. This attitude may be
acceptable when shooting stills, but

Color correction cards

These two Gretag-Macbeth (now X-Rite) color correction cards are the two most commonly used. On the left is the Digital ColorChecker SG, and on the right, the ColorChecker Color Rendition Chart. Both cards are 28 cm wide, and the Color Rendition Chart is also available in an 8.2 cm mini version for use with smaller subjects.

is positively slapdash when shooting video. When shooting stills, you can always shoot a bracketing sequence and select your best shot later—an approach that is simply not possible when shooting video. As yet, there is no RAW video format for making wide-ranging corrections to poorly exposed footage. For video clips, it is critical to get your exposure right while shooting.

You can use a separate light meter to gauge the lighting at various points in your scene, making it much easier to select the correct manual exposure settings or automatic exposure compensation values.

Clapperboard

Outdated or not? The answer to this question is a definite maybe. A clapperboard is still a useful visual tool for recording information regarding the individual shots in a video project, even if date and time data are automatically recorded in digital video files.

A simple analog clapperboard has to be freshly labeled before every scene, although the details for the

Using a color correction card

In difficult lighting situations (here the interior of a yacht), color correction cards can be used to help correct poorly exposed colors during post-processing. The test shot with the color card in it can be corrected so that the sample colors are correctly exposed. The same correction parameters are then applied to the entire clip, resulting (hopefully) in a perfectly exposed sequence.

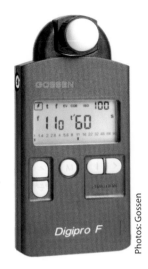

Photos: Gossen

Modern light meters

Clapperboards
Left: a simple plexiglass model Right: a model with a built-in timecode display

title, director, and camera operator will usually remain unchanged during the entire production. The variable data that has to be continually updated are the shot, scene, and take numbers.

In the movie world the clapperboard is also used to record the film type and information regarding day or night and indoor or outdoor shooting, as well as whether live sound was recorded with the visuals.

Some movie clapperboards have built-in timecode displays, but these are superfluous when shooting digital video, as editing software can read this information directly from the individual video files.

Photo: Nikon

Camera with a **GPS module** attached

GPS data in an EXIF file header

This Adobe Bridge screenshot shows the GPS tags stored in the EXIF file header

GPS receiver

Some cameras have built-in GPS receivers or connectors for GPS devices, but limitations in video data formats mean that no current model is capable of integrating geotags (i.e., GPS coordinates) directly into video footage. The difficulty lies in the fact that the camera's physical position can change during a video shot. In contrast, the place and time a photo is taken is always precisely identifiable.

Some DSLRs save a photo along with each video sequence, which can then be geotagged, making identification of (the start of) the following scene easier. These photos also serve as a visual reminder of the location where the clip was shot.

If your camera doesn't automatically save a photo with each sequence you can, of course, take a quick, taggable snap of your scene yourself before you start filming.

Different GPS devices record differing data in the file header, based on a basic range of 31 different parameters. The most important data are latitude and longitude (for the precise identification of the location), as well as altitude above sea level and the direction the camera was facing while shooting. Useful additional GPS information includes UTC date and time coordinates which are, in contrast to many built-in camera clocks, always correct.

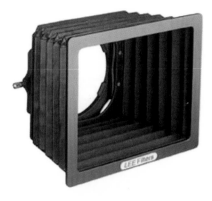

Lens hood
Simple bellows-type lens hood for direct mounting on the lens

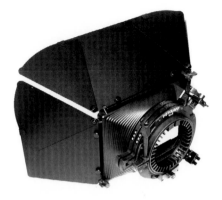

Matte box
A compendium with adjustable wings or "barn doors" is a common video accessory

These are all useful aids when you are sorting your footage after the shoot.

Dedicated Video Accessories for DSLRs

Video accessory manufacturers have recently begun to introduce dedicated DSLR video accessories, making DSLRs increasingly more versatile and professional than their video camera counterparts. Such accessories are not cheap, and can cost more than the camera itself, but they are nevertheless worthwhile extensions to your kit and make shooting HD video even more fun.

Lens Hoods and Matte Boxes

Conventional lens shades are designed to work with a camera's still image format, and are thus not suitable for shooting video. They do not provide sufficient shade, especially for narrower video formats, such as 16:9. Video lens hoods are called matte boxes (or sometimes compendiums), and are adjustable to suit various combinations of shooting format, focal length, and working aperture. Video lens hoods are generally of a simple, bellows type or, more often, have adjustable "barn door" wings. Matte boxes usually have a built-in filter holder.

Filters

Filters are just as popular among videographers as they are among

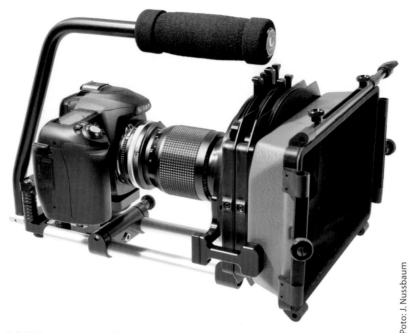

Poto: J. Nussbaum

A DSLR set up as a video camera, complete with a matte box
Here, the camera is mounted on a lightweight camcorder grip
that aids use of the matte box

Tips & Tricks

Note that the effects of some filters
are dependent on the selected
aperture. Some filter effects also
change during zooming.

photographers. You can attach filters
to the filter thread of your lens in
the normal way or, if you are using
a matte box, you can insert them
directly into the built-in filter slots.

Color filters and **color correction
filters** are a simple tool for altering
the lighting mood of your scene. A
blue filter produces cold-looking light
while an orange filter helps the scene
to appear warmer.

Polarizing filters are useful if you
need to reduce the reflections caused
by smooth surfaces such as glass or
water. They can also be used to inten-
sify greens (for example, in plants
and trees), and also help to increase
the contrast between clouds and blue
sky.

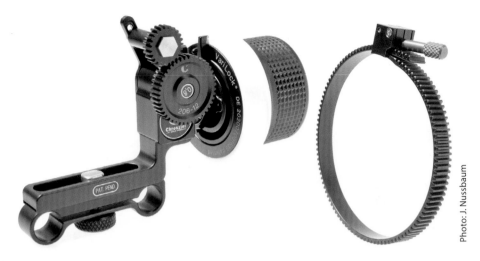

Photo: J. Nussbaum

Follow focus

A follow focus consists of an adjustable, geared ring attached to the focus ring on the lens and a set of gears driven by a hand-wheel. This device makes it easier to focus quickly, smoothly, and precisely

Neutral density (ND) filters are gray colored and reduce the total amount of light entering the lens without altering its color. They can be used to lengthen the shutter speed when shooting with a pre-selected aperture—an effect that is often used to retain the desired level of motion blur when shooting fast moving subjects. If moving subjects are filmed using a shutter speed that is too short, the resulting action can appear jerky.

ND filters are generally available with filter factors of 2, 4, or 8.

Variable ND filters are also available, and are constructed of two rotating linear polarizing filters which can be set to a filter factor of between 2 and 8. The lowest factor is achieved when the polarizers are parallel to each other, and increases as the two filters are moved toward a perpendicular setting. Remember that variable ND filters are based on polarizing elements, and can affect the overall appearance of your scene.

Graduated filters are often used for outdoor scenes in which the sky is bright and untextured and the foreground is already dark. A blue-to-clear graduated filter helps to intensify the color of the sky without further darkening the rest of the

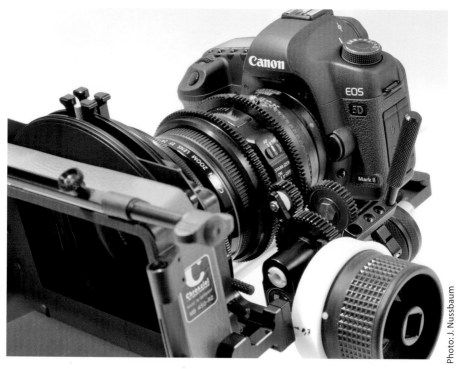

Complete, high-end video DSLR setup
This full-blooded video DSLR is equipped with a matte box, a
follow focus, and a fluid zoom drive

frame. You can also use **graduated ND filters** to make the sky appear darker without altering its color.

Follow Focus

The focus ring on a DSLR's lens is designed for setting focus before an exposure, not for subtly altering focus during a video shot. A follow focus is a device consisting of a toothed ring attached to the focus ring on the lens, and a geared hand-wheel that is used to rotate the ring.

This setup allows you to adjust focus much more subtly and smoothly than you can using the focus ring itself.

Follow focus units developed for use with DSLRs are usually mounted on a bracket with a hand grip or shoulder pad. This arrangement not only makes it easier to attach various accessories to the camera, but also makes it easier to carry the entire unit once it has been bolted together.

Follow focus units can also be used to preset your field of focus, so that

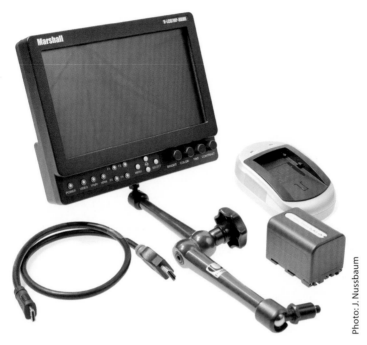

A little luxury
A large, bolt-on monitor makes shooting a lot easier

Photo: J. Nussbaum

you can focus precisely between your chosen extremes without even having to look at the focusing wheel.

Fluid Zoom Drive

A fluid zoom drive is a professional-grade accessory that uses a fluid-damped ring and lever assembly to help you zoom your lens more smoothly and precisely than you can using the built-in zoom ring.

External Monitor

The be-all and end-all accessory for DLSR video enthusiasts is an external, bracket-mounted monitor. A large, bright monitor that can be viewed even in bright sunlight makes shooting a real pleasure and allows you to judge focus, exposure, framing, and image composition much better than on the camera's built-in monitor. Quality monitors also have dedicated focus and exposure display modes.

Shooting Techniques

by Helmut Kraus

From Concept to Finished Film

Although spontaneous shots often produce great photos or video, it is always helpful to have an idea of the result you are aiming for before you start shooting. Spontaneous still shots are more common than spontaneous video sequences, and video shot "from the hip" will usually end up as part of a longer, more complex finished film. Shooting video generally requires a good deal more planning than a photo shoot due to the complexity of the shooting process, and because you will usually spend much more time at each location.

You should also have a clear idea of how you want to present your finished work before you start shooting. A single photo can be simply handed around, but viewing a video requires the use of a computer, a monitor, or a projector.

Although various tips and tricks apply to specific genres, we will use the following sections to look at general techniques that apply to all types of video, whether you are shooting classic news and reportage, or whether you prefer shooting music, wedding, or vacation video.

The DSLR video techniques we describe can be applied just as well to a record of a family outing as to a professionally produced advertising spot or a drama. When shooting video, the actual technique you use is less important than making sure you keep your mistakes to a minimum.

Choosing Your Location

Zoom lenses have turned photographers into lazy creatures. Instead of taking a step or two toward or away from a subject, it is nowadays instinctive to simply zoom in or out.

This is one of the risks involved in shooting with a modern digital camera. Nowadays, too many photographers and filmmakers rely on a change of focal length to properly frame their shot rather than spending more time searching for a suitable camera position before shooting.

A careful choice of camera position is more important when shooting video, as you will usually spend more time at each individual location. As well as the aesthetic considerations, the practical aspects of a video location are also important. For example, if you want to photograph a scene on a busy street, you can usually use a quiet moment to step between the traffic and take your shot. If, however, you want to shoot video of the same street, you will have to use a different approach if you don't happen to have the police on hand to help you close the street while you work. A photographer can simply ignore background noise from trains and airplanes, and can wait

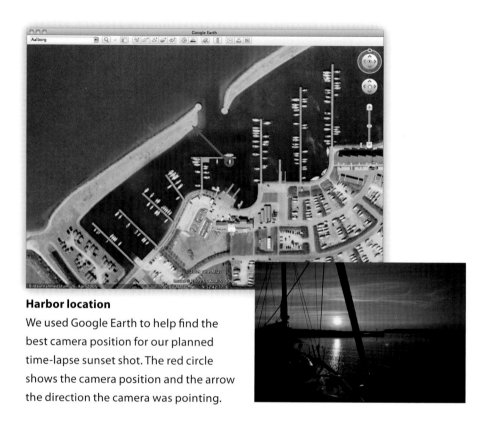

Harbor location

We used Google Earth to help find the best camera position for our planned time-lapse sunset shot. The red circle shows the camera position and the arrow the direction the camera was pointing.

for people near the scene to pass by. Similar disturbances can drive a film-maker crazy.

When shooting video, you need to plan so that your shooting conditions remain constant during the entire take (or even multiple takes). Film-ing interviews outdoors under light cloud is a common mistake. Here, the interviewee starts his answer with his face in the shade and then starts to blink while he is speaking due to the sun coming out in mid-shot—such a shot will have to be repeated until it works out.

Google Earth is a great tool for checking locations in advance. You can use the time and date settings to show the lighting situation for any given moment and, with a little geographical knowledge, you will be able to estimate the angle of the sun and the potential movements of the shadows in your shot.

Pierre Marie Granger's fantastic reference book
Die Optik in der Bildgestaltung

Selecting Focal Length

Every serious filmmaker should
take a look at Pierre Marie Granger's
wonderful book *Die Optik in der Bildg-
estaltung* (roughly translated: "Optics
in Image Composition"). This volume
was unfortunately only ever pub-
lished in German and French, but is
nevertheless well worth a look if you
can find a copy. The book takes a com-
prehensive look at the effects of the
laws of optics on creative film-mak-
ing. The author demonstrates that
the lens not only produces the image,
but that it is also the real creative ele-
ment when it comes to taking photos
or shooting film. If you are familiar
with the optical characteristics of
your tools and the physical laws that

govern how they function, you will be
able to maximize your own creative
potential. It is beyond the scope of
this book to go into Granger's work
in depth, but we will here summarize
a few of his thoughts on the subject
of framing and choice of aperture to
whet your appetite.

But first, an important film and
photographic definition: a "normal"
lens is a lens whose focal length is
the same as the diagonal length of
the shooting format. A normal lens
for a digital camera therefore has a
focal length equivalent to the diago-
nal length of its image sensor. The
formula for calculating the angle of
view of an optical system tells us the
angle of view for a normal lens is 53

Sensor format	Wide-angle focal lengths	Standard (normal) focal lengths	Telephoto focal lengths
Full-frame	< 36 mm	43 mm	> 86 mm
APS-C & DX	< 23 mm	28 mm	> 56 mm
Four Thirds	< 17 mm	22 mm	> 44 mm

Sensor formats and focal lengths: effective focal lengths for wide-angle, standard, and telephoto lenses

Effective HD video sensor area
In movie mode, many cameras gray out the unused parts of the frame.

degrees—but that's enough math and physics for now.

Coincidentally, the 53-degree angle of view is very similar to the field of view that the human eye can see in sharp focus. (Although this may not be a coincidence—many biological phenomena directly obey the laws of physics.) Human vision actually covers a horizontal field of view of more than 180 degrees, but we can only perceive brightness and movement

Full-frame sensor Nikon DX/Canon 1.6x (APS-C) format Four Thirds

Sensor type	Photo sensor area	Video sensor area
Full-frame	36 × 24 mm	36 × 20 mm
Nikon DX	23.6 × 15.8 mm	23.6 × 13.3 mm
Canon 1.6x (APS-C)	22.3 × 14.9 mm	22.3 × 12.5 mm
Four Thirds	17.3 × 13 mm	17.3 × 9.7 mm

HD video sensor area
The aspect ratio of HD video means that the full height of the image sensor is not used when shooting video. The illustrations on the left show the various sensor types and their effective photo and video sensor areas at life size.

over the full range, and we cannot see in focus at the extremes of our peripheral vision.

Focal lengths that are shorter than the width of the shooting format cover an angle of view greater than 53 degrees and are generally described as wide-angle lenses. Longer focal lengths cover narrower angles of view, and focal lengths greater than twice the format diagonal are described as telephoto lenses. For a full-frame camera, this equates to a wide-angle range starting at 36 mm and a telephoto range that begins at around 85 mm. Lenses in the range between format width and twice the format diagonal are described as short or long standard lenses. Most fixed focal length digital compacts have built-in short standard lenses, while some 35mm-format macro lenses have longer, 60mm standard focal lengths.

Differences between Photo and Video Formats

When shooting 16:9 HD video, a full-frame camera with a 24 × 36 mm sensor exposes a 20 × 36 mm portion of the image sensor to light. Photo formats have aspect ratios of either 4:3 (Four Thirds sensors) or 3:2. APS-C and DX-format cameras expose a 13.5 × 24 mm portion of the sensor (instead of the full 16 × 24 mm) and Four Thirds cameras use a 9.7 × 17.3 mm area instead of the full 13 × 17.3 mm.

The definition of a normal lens (see above) therefore results in a standard focal length of around 40 mm for video shot using a full-frame camera. The same calculation results in a standard focal length of approximately 28 mm for APS-C sensors and 20 mm for the Four Thirds format.

This is why it is important to remember to use the height of the video format (not the image sensor) as the basis for all your calculations in the following sections.

Framing Using Formulas

Before starting to shoot, you have to make a number of decisions and answer a number of questions, many of which can be answered with the help of a simple mathematical formula. This formula states that the size of the image has the same relation to the size of the subject as the focal length has to the subject distance and can help to determine

camera position, framing, or the choice of focal length for a shot:

$$\frac{\text{Image size}}{\text{Subject size}} = \frac{\text{Focal length}}{\text{Subject distance}}$$

Granger states this as follows:

Image/Subject =
Focal length/Distance

or, stated as a product:

Image · Focal length =
Subject · Distance.

The formula can be stated with each of its four variables as its subject, resulting in the following four basic versions:

$$\text{Subject dist.} = \frac{\text{Object size} \cdot \text{Focal length}}{\text{Image size}}$$

or

$$\text{Image size} = \frac{\text{Subject size} \cdot \text{Focal length}}{\text{Subject dist.}}$$

or

$$\text{Subject size} = \frac{\text{Subject dist.} \cdot \text{Image size}}{\text{Focal length}}$$

or

$$\text{Focal length} = \frac{\text{Subject dist.} \cdot \text{Image size}}{\text{Subject size}}$$

It is impossible to stress the importance of this simple idea enough when it comes to answering fundamental film or photographic questions. Once you have grasped this principle, you will see how easy it is

Focal length	Width × height of the image field at 1 m distance in HD format		
	Full-frame (36 × 20 mm)	DX / APS-C (approx. 23 × 13 mm)	Four Thirds (17 × 9.7 mm)
14 mm	2.57 m × 1.43 m	1.64 m × 0.93 m	1.21 m × 0.69 m
28 mm	1.23 m × 0.71 m	0.82 m × 0.46 m	0.61 m × 0.34 m
35 mm	1.03 m × 0.57 m	0.66 m × 0.37 m	0.49 m × 0.28 m
50 mm	0.72 m × 0.40 m	0.46 m × 0.26 m	0.34 m × 0.19 m
80 mm	0.45 m × 0.25 m	0.29 m × 0.16 m	0.21 m × 0.12 m
135 mm	0.23 m × 0.15 m	0.17 m × 0.10 m	0.13 m × 0.07 m
200 mm	0.18 m × 0.10 m	0.11 m × 0.06 m	0.09 m × 0.05 m

Image field sizes at 1 m distance
for HD video shot using various DSLR sensor formats

to use the basic laws of optics to help you with your photo and video work.

Let's take a look at the last formula using an example. A six-foot person is to be filmed to fill the (20 mm) frame at a distance of seven meters using a full-frame camera. What focal length lens do we need to use?

Our formula provides the answer:

$$\text{Focal length} = \frac{7\,\text{m} \cdot 20\,\text{mm}}{2\,\text{m}} = 70\,\text{mm}$$

At a distance of 7 meters, I can fill the frame with my subject using a 70mm lens. The mathematicians among you might be asking yourselves how it is possible to mix meters and millimeters in a single formula. The answer is simple: as long as we stick to one unit in the physical realm (subject size and distance) and one unit in the optical realm (focal length and image size), nothing can go wrong. If you want to check your results, you can use meters for all your variables (unfortunately not very practical for measuring focal lengths), or you can measure everything in millimeters, which makes measuring distances just as complicated. The result remains the same whichever method you use.

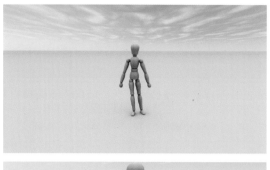

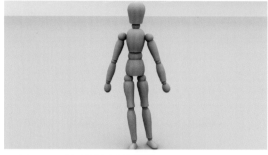

Differing magnification
Shot at various magnifications from the same position
Top: 24 mm focal length, 5 m subject distance
Center: 50 mm focal length, 5 m subject distance
Bottom: 200 mm focal length, 5 m subject distance

Focal Length and Image Field

The focal length of a lens determines the size of the image field captured by the image sensor. The table lists the size of the image field for various common focal lengths and sensor types for a subject that is one meter from the camera. To compute the image field size for other distances you either have to multiply the given field size by the new distance or use the formula described above. Let's look at an example of an image field. Our subject is, once again, a six-foot person who is to be filmed using 24mm, a 50mm, and a 200mm lens at a distance of 5 meters.

If we alter the subject distance for the wide-angle and telephoto lenses so that the subject appears at the

Differing focal length
Shot using different lenses
from different positions
Top: 24 mm focal length,
2.4 m subject distance
Center: 50 mm focal length,
5 m subject distance
Bottom: 200 mm focal length,
20 m subject distance

same size as he does when filmed
using the standard lens, the subject
distance will be 2.4 meters for the
wide-angle lens and 20 meters for the
telephoto.

Focal Length and Perspective

The main factor influencing the per-
spective of a shot is camera position.
You can check this by taking shots
of your subject from the same place
using different focal length lenses
and comparing enlarged sections
of each image with a wide-angle
shot. Apart from the resolution, the
images will all appear the same.

It is nevertheless true to say that
the focal length of a lens also affects
perspective, as the focal length we
select to portray our subject depends

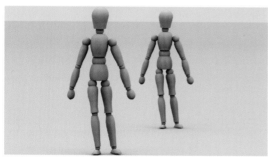

Different perspectives
Two subjects filmed at varying distances to the camera using different lenses
Top: 24 mm focal length, 2.4 and 7.4 m distances
Center: 50 mm focal length, 5 and 10 m distances
Bottom: 200 mm focal length, 20 and 25 m distances

on our location. This idea is best illustrated by looking at two images of a subject shot at different distances. If a second person stands five meters behind our subject in the previous example, our two subjects will appear to be of different sizes from image to image. Simply put, perspective changes with a changing camera position. The wide-angle shot shows the greatest size difference and the telephoto shot the least. The size of the foremost subject remains constant throughout the experiment.

Interestingly, the standard lens portrays the second subject with half the size of the first. In this case, the viewer will (correctly) assume that the second subject is twice as far from the camera as the first. The

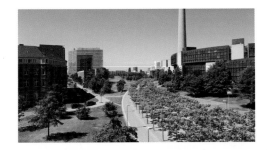

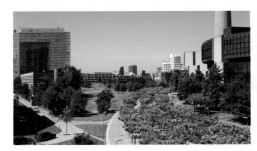

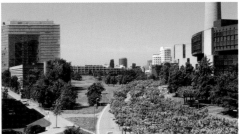

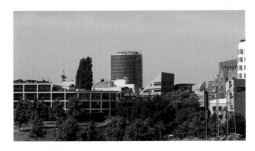

Using different focal lengths instead of enlargements
Wide-angle, standard, and telephoto shots taken from the same position compared with enlargements taken from the wide-angle shot. The only difference is the resolution.

Top left: 24mm shot
Center left: 50mm shot
Bottom left: 200mm shot
Center right: Equivalent enlargement taken from the 24mm shot
Bottom right: Equivalent enlargement taken from the 24mm shot

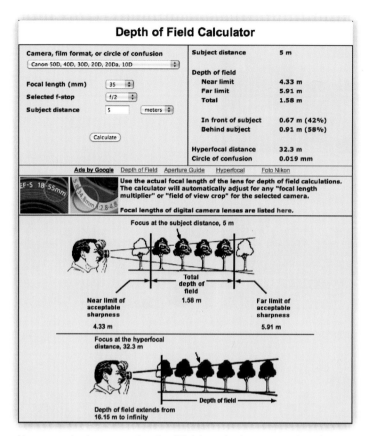

You can calculate your depth of field on the Internet using the free tool available at www.dofmaster.com

"perspective" reproduced by the standard lens appears natural and the assumed geometry of the scene represents reality as we see it. The wide-angle view intensifies the normal perspective with the subject at the rear appearing smaller than it actually is. The telephoto view produces the opposite effect, making the second subject appear larger and closer than is actually the case.

It is difficult to judge the real relative sizes of objects in a wide-angle or telephoto scene. Hollywood directors often use this effect to deliberately fool moviegoers into thinking that film stars are physically bigger than they actually are.

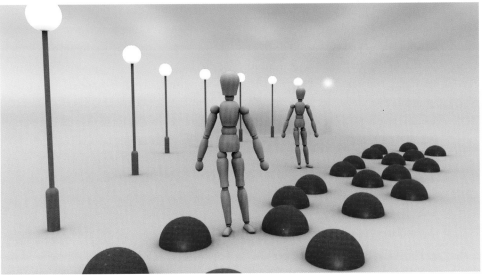

Selecting the best field of focus

Above: optimum field of focus

Below: over-extended field of focus

The differences in depth of field are clearly recognizable in the streetlights. In the lower image, they are too sharp and distract the viewer from the actual subject.

Aperture and Depth of Field

This book generally assumes the **shallow** depth of field that large sensors can produce is the factor that most influences the movie-like look of HD video shot using DSLRs. There are nevertheless many situations that require deliberate use of greater—or better put, controlled—depth of field.

The aperture you use determines the extent of the available depth of field and is therefore critical to the final appearance of a scene. For this reason, you should always control exposure by varying sensor sensitivity (i.e., the ISO value) or by adjusting your shutter speed, not by changing the selected aperture. The combination of sensor size, focal length, working aperture, and subject distance determines the precise extent of the depth of field in your scene. Familiarizing yourself with these relationships will enable you to precisely control focus and help you to produce clear, meaningful clips. Depending on your knowledge level, I could shock, overstretch, or simply bore you by explaining the math involved, but it's probably easier to refer to programs that do all the work for you. For example, DOFMaster (www.dofmaster.com) is a simple, free Web app that is also available for just about every common IT platform, including iPhone.

As an example for the type of situation every filmmaker should be able to master, let's assume we are filming a group of people positioned between 5 and 10 m from the camera. If we set up the camera to keep this range of distances in focus, we won't need to adjust focus during the shot. This not only makes shooting easier, but ensures that the viewer is not distracted by out-of-focus detail when viewing the scene later on. For our example, the depth-of-field calculator tells us that a 35mm lens used with an APS-C sensor must be stopped down to at least f/3.4 in order to be able to focus at a distance of 5 m or more. If we focus our lens to 6.6 m, the resulting field of focus ranges between 4.9 and 10 m—problem solved! The total depth of field here keeps the background blurred enough so as not to distract the viewer from the main action.

This example is intended to emphasize the importance of planning depth of field before shooting. You could, of course, shoot the same scene at f/9 from a distance of 7.5 m, but the result would be a very different one, with everything from a distance of 3.7 m right up to infinity in sharp focus. This would significantly change the emphasis in the frame, possibly diverting the viewer's attention away from the real center of the action.

$$\text{Middle distance} = \frac{\text{Near distance} \cdot \text{Far distance} \cdot 2}{\text{Near distance} + \text{Far distance}}$$

Formula for calculating middle distance
This formula is used to calculate the focus setting necessary to keep a specific distance range (between "near distance" and "far distance") in focus.

Calculating depth-of-field in advance allows controlled use of focus and blur effects to emphasize important elements of a scene, and is a tool that every filmmaker should know and use.

Granger once said: **"Depth of field is not a guillotine"**, meaning that the rest of a scene doesn't suddenly plunge into blurred nothingness beyond the field of focus. The transition from sharp to unsharp is progressive, and the more extensive the field of focus, the less blurred the rest of the scene will be. I recommend using exactly the calculated aperture value, as stopping down "for safety's sake" often produces less effective results.

Distance Settings

What is the best way to focus if you don't wish to make precise depth-of-field calculations? For subjects that have little depth of their own, you can simply focus on the subject in photo mode (if necessary, with the help of autofocus), switch autofocus off and film in Live View mode. If you are filming a person, focusing on the eyes is the best way to ensure that they stay in focus from the tip of the nose to the back of the head.

If you want to film two people positioned 5 and 10 m from the camera, the basic rule says that focus should be set for the foremost third of the field of focus. Here, we would focus at 6.7 m (one third of the distance between the two subjects plus the distance from the camera.

Mathematically minded readers can also use a formula to calculate the position of the optical middle distance (see below). Strict use of this formula helps you to avoid unnecessary blur in your shot. If we focus

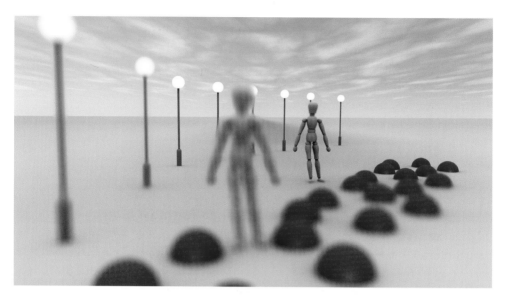

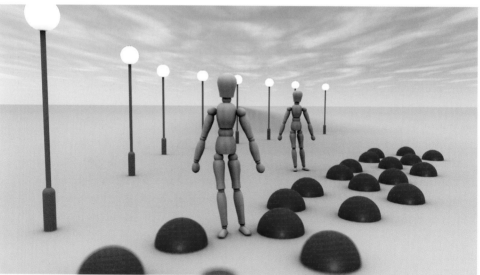

Hyperfocus

Top: focusing on infinity does not provide sufficient depth of field, and the figure in the foreground is out of focus.

Bottom: with the lens focused at its hyperfocal distance, the depth of the field of focus is sufficient to cover the foreground and all other detail right up to infinity. Detail in front of the foremost figure is not in focus.

exactly between the two subjects in our example (i.e., at 7.5 m), the closer subject would be blurred if filmed using a large aperture, while the resulting field of focus would stretch further than necessary beyond the rear subject.

Hyperfocus

Every lens has a specific hyperfocal distance for each aperture setting beyond which all objects can be brought into focus. The proximity of the the hyperfocal distance to the front of the lens depends on the aperture, and the smaller it is, the closer it will be.

Let's look at an example. We want to produce the deepest possible field of focus at f/2.8 using a camera with a DX-format sensor and a 35mm lens. If we were to focus at infinity, we would lose focus in large portions of the foreground, and the given settings would capture all detail from a distance of 23 m up to infinity in sharp focus. If, however, we were to set the lens to its hyperfocal distance, the range of sharp focus would extend from 11 m to infinity. The resulting "lost" 12 m of in-focus detail could make a big difference to the appearance of a shot in the real world.

The hyperfocal distance is a useful value to bear in mind if you want to keep your shot in focus right up to infinity.

Exposure and White Balance

If you reframe your shot, you run the risk of changing the lighting, and with it exposure and color temperature. Changes in lighting can also occur without moving the camera—for example, under moving clouds or when the sun comes out. It is important to make sure that color and exposure remain constant throughout video clips, especially where zooms and pans are involved.

Consistent Lighting

There is no generalized method of ensuring consistent lighting during a shot. Sometimes, the camera's automatic exposure systems compensate well for changes in lighting and produce great results. However, settings that are too general can cause automatic exposure systems to overcompensate for increasing brightness and darken the subject too much.

Under some circumstances, center-weighted metering can produce ideal results, while matrix metering is better for other scenes. Although the metering mode you use is very important to the final result, there is no surefire way of ensuring you select the right one.

Spot metering is useful when multiple subjects are variously lit, while matrix metering is the better choice if you want to reframe a shot by zooming during a take. Very

generally speaking, matrix metering is better for scenes that contain detail at infinity, while scenes with mainly foreground detail are better handled using spot metering.

Consistent Color Temperature

Human vision is blessed with an extremely sensitive built-in color balance system. If we move from bright sunlight into an artificially lit room, our eyes automatically compensate and we don't notice the changes in color or the composition of the prevailing light. If, however, we switch off the automatic white balance in our camera and shoot an outdoor shot followed by an indoor shot, the changes in color temperature will be obvious in the resulting images.

It is neither possible nor desirable to make sudden changes to white balance settings during a video shot, so we simply have to hope that the camera's systems do a good job.

It is nevertheless best to set white balance manually for consistently lit scenes. This way, you can be sure that white balance won't change during a shot. Adjusting video white balance during post-processing always results in an overall loss of image quality.

Incorrect white balance
Here, white balance was set manually for the cool spring daylight during the whole shot, causing an obvious color cast in the interior and shaded parts of the sequence

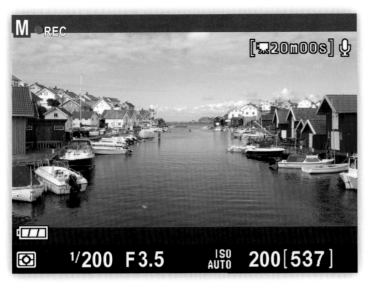

Camera monitor with aperture/shutter speed display
Don't be fooled by Live View display values! These are usually
only valid for photos but not for video shots. Most cameras
select the video shutter speed automatically, irrespective of the
value shown in the display.

Shutter Speeds

In contrast to analog movie cameras
and high-quality video cameras, most
digital cameras (and especially com-
pact and bridge cameras) do not allow
you to set your video shutter speed
manually. The camera selects the
shutter speed automatically depend-
ing on the lighting situation and
the aperture you have selected. The
available shutter speeds are usually
quite limited; the Canon 5D Mark
II, for example, has a video shutter
speed range between 1/30 and 1/125
second. Shutter speeds above 1/24

second are not possible due to the
camera's 24 fps movie frame rate,
and shutter speeds shorter than
1/125 second would provide too
little motion blur, making movement
appear jerky. Even if your camera
allows you to select shutter speeds
manually, you should use a value
within this range.

In Live View mode, most cameras
display shutter speed and aperture
on the monitor, but remember, only
the aperture value is accurate when
you are shooting video.

Shooting position using a camera with a swivel/tilt display

Tripod or Handheld?

The human body has excellent shock absorbing and three-dimensional movement properties as well as a direct connection to the photographer's brain, and is consequently a very good natural tripod. Many scenes and even entire films can be shot using only small additions to the photographer/camera interface, such as a camera grip or a steadycam.

Cameras with tiltable monitors allow you to hold your camera steadily without muscle strain, and you can look down into the monitor, the same way you would when using an old-fashioned medium format camera with a waist-level viewfinder. Shooting from this position also has the additional advantage that most

subjects don't think they are being filmed.

If you look around, you will find that the world is full of natural camera supports, and resting the camera on a wall or a tree branch often provides just as much stability as a purpose-built tripod.

Just about any vehicle can also serve as a camera support. All you need to do is find a suitable connector for your camera. The photo accessory market is never slow to catch on, and there are a multitude of magnets, suction cups, beanbags, and other devices available for attaching cameras to all manner of objects.

Once you have fixed your camera to your vehicle, you are free to shoot whatever action you please. YouTube and Vimeo are full of examples of exciting, dynamic HD video shot in countless action sport scenarios, from surfboard to mountain bike or even from a parachute.

Time-lapse Sequences

Time-lapse sequences offer a new and fascinating view of the world, but are usually only realizable using complex equipment. A DSLR is, on the other hand, an ideal tool for experimenting with this exciting technique.

Just like a conventional video clip, a time-lapse sequence is comprised of a series of individual images shot at

regular intervals, but with intervals that are simply longer than the usual 1/24 second. It is possible to shoot sequences of images at user-defined intervals using any camera, making it not strictly necessary for your camera to have a video mode in order to shoot time-lapse sequences, but it's still fun to try out.

The key to shooting time-lapse video is your camera's interval timer, which allows you to shoot sequences of images at fixed, predefined intervals. These are then merged into a single, finished time-lapse video clip.

Interval timers vary slightly from manufacturer to manufacturer, but all work in basically the same way. Before pressing the shutter-button, you have to set a start time, the interval between shots, and the number of shots you wish to shoot. Once started, the camera will shoot the entire programmed sequence without stopping.

It is usually necessary to make some calculations or to experiment a little (or both) before setting the parameters for your sequence. It can be tricky to estimate the best interval for your chosen subject. For example, if you are filming moving clouds, too short an interval will cause the clouds to move too quickly through the frame, while shooting with an interval that is too long will have the opposite effect. If you are not sure,

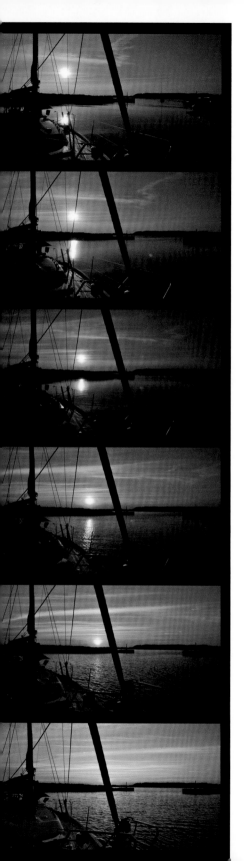

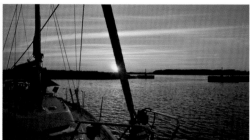

Time-lapse sequence of a sunset

The individual images in this time-lapse
sequence were taken at 1-minute intervals.
The two consecutive images above are taken
from a total of 88 that make up the finished
14-second video sequence.

The film strip on the left shows six consecutive
images from the sequence taken over a period
of fifteen minutes.

simply shoot a short test sequence to check your settings in advance.

A sunset is easier to film if you know approximately how long it will be until the sun disappears over the horizon and how long you want your finished sequence to last. If, for example, you want to make a 15-second sequence out of an hour's sunset, you will (at 24 fps) have to shoot 24 × 15 = 360 individual shots to create your sequence. An hour has 3,600 seconds, so you will need to set your camera to take one shot every 10 seconds in order to shoot the required 360 images within the available time.

It is more difficult to work out where the sun will actually cross the horizon, and you will have to rely on either your memory of the day before or a compass and an astronomical program for your computer if you want the sun to disappear exactly in the center of the frame.

It is always better to take too many shots in a time-lapse sequence than too few. If your finished sequence appears too slow, you can always cut out every second shot to speed things up. If, however, your sequence appears to move too fast, it is impossible to slow things down without reshooting using a shorter interval.

It is advisable to set your camera to a lower, video-level resolution before shooting in order to avoid having to resample each high-resolution image to a lower resolution before merging them into the final clip. If your camera can't shoot at such low resolutions, you will need to use an appropriate tool, such as QuickTime Pro (for Mac) or Adobe Premiere Elements (for Windows) to batch-process your images before merging.

Stop Motion Sequences

Creative image composition and manual exposure functionality make DSLRs great tools for creating stop motion animations. Stop motion is the oldest of all animation techniques, and was used to breathe life into all the earliest movie monsters, from Godzilla to King Kong. The basic principle is the same as that for time-lapse sequences, with individually shot frames being merged into a single, finished clip.

The use of high-end gear (including macro or tilt/shift lenses) makes it possible for today's DSLR owner to shoot extremely professional-looking animations.

You can also use stop motion techniques to give your results a deliberately trashy look by shooting long sequences of handheld stills at your camera's highest burst rate. If you then merge the resulting images into a single video sequence, the results end up looking like a deliberately ham-fisted stop motion animation. If you enhance this effect by shooting

Capturing movements in slow motion
Scenes like this one of a stork coming in to land are even more impressive if shown in slow motion. In order to produce slow motion effects, your camera must be capable of shooting at high frame rates.

with an ultra-wide-angle lens or a bright lens with its aperture opened right up, you can produce truly unique-looking footage. A little color tuning during post-processing also works wonders. Definitely worth a try ...

Slow Motion

Slow motion sequences show detail that is otherwise invisible to the naked eye. Human or animal movements often take on an especially graceful calm when filmed in slow motion.

Unfortunately, DSLRs are of only limited use for shooting slow motion sequences, and can only be practically used to realize decelerations with a factor of 2 or 3. In order to shoot slow motion at all, your camera must be able to shoot at frame rates higher than 24 fps. For example, footage shot at 60 fps will be decelerated by a factor of 3 if it is played back at 20 fps. Twenty fps is, however, the absolute limit for acceptable playback quality, and slower playback rates make your sequence look as if it was shot using stop motion techniques. Sixty fps footage played back at 30 fps, or 50 fps footage played back at 25 fps produce much better-looking results. Sequences shot at 30, 24, or 20 fps are not suitable for use with slow motion applications.

Video as an Extension of the Photographic Medium

The German comedian Karl Valentin once said: "Making films is wonderful, but it sure is hard work". Considering that photo cameras are the actual subject of this book, photography has, so far, drawn a short straw. But don't panic, the rest of the book is about shooting video too. We will nevertheless use the rest of this section to address video less as an independent pursuit and more as a means of enhancing the existing photographic medium.

Until now, photographers were generally not interested in the fact that unsolvable photographic problems could be easily solved with the help of film or video techniques—if only because most photographers didn't have access to film equipment. Additionally, it has not been possible, until recently, to combine film and photos in a single presentation. Nowadays, the availability of DSLRs with video modes and the advent of computers and digital projectors make it possible to shoot and present both media using a single tool. This in turn allows photographers to address themes and ideas that were previously unthinkable.

Panorama Views

Documentary photos are often disappointing and don't adequately capture the photographer's original intention. The viewer (who was not present at the original location) often sees a great photo, but this doesn't help the poor photographer who still doesn't see—and, more importantly, feel—the original scene in the photo on the wall.

Panorama landscapes are a good example of such a scenario. Let's assume you are standing on a cliff and that you are emotionally moved by the grandiose view into the abyss. You grab your impossibly expensive ultra-bright, super-coated, wide-angle lens and attempt to capture your feelings in a photo. Viewing the results later on your computer monitor is often a big disappointment.

Further attempts to take multiple photos of the same scene, viewed either as a series with cross-fade effects or even merged together as a panorama, still end in disappointment.

This is where video can help. The third attempt to capture the elusive panorama involves selecting a lens that covers a sufficient vertical angle of view and mounting the camera on a tripod with a high-quality video head. You can then take a slow, panned shot of the entire panorama that perfectly reproduces the feeling of grandiose space that you couldn't

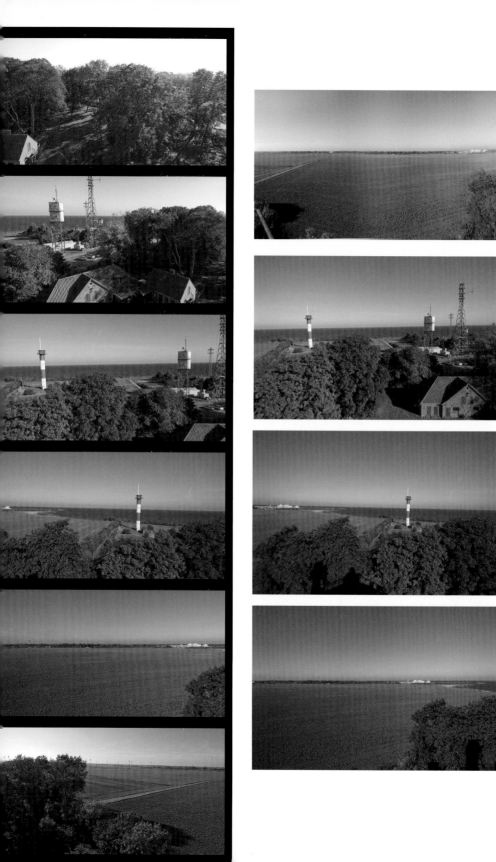

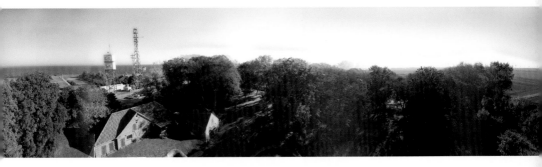

Panorama view from a lighthouse

The view from the tower is fantastic but the wide-angle photo is not very impressive, in spite of the 18mm ultra-wide-angle lens used to take it! A series of wide-angle shots doesn't do the view justice either.

One possible solution in this situation would be to create a panorama image using several wide-angle shots, although that would involve a lot of work, and the extreme angle of view of the lens makes it difficult to overlap the individual images precisely. Such extreme formats are also tricky to present.

A simpler solution is to capture the view using a panned video shot, illustrated here by the sample frames in the film strip on the left.

capture in a photo. You can even intensify this feeling with a clever combination of photos and video clips in a single presentation with musical accompaniment.

Reducing Distance

Telephoto landscape shots are nice to look at but produce views that look as if they were shot through binoculars. The problem here is that the viewer cannot see the landscape itself, and thus cannot compare the real "uncompressed" view with the one reproduced in the photo.

Here, it is advisable to present a sequence that leads the viewer's eye slowly into the landscape, especially if the presentation is of a documentary nature.

Video mode gives you two ways to show more of a landscape. If your lens has a sufficient range of focal lengths, you can zoom right into your scene. Alternatively, a tracking (or dolly) shot provides a view with

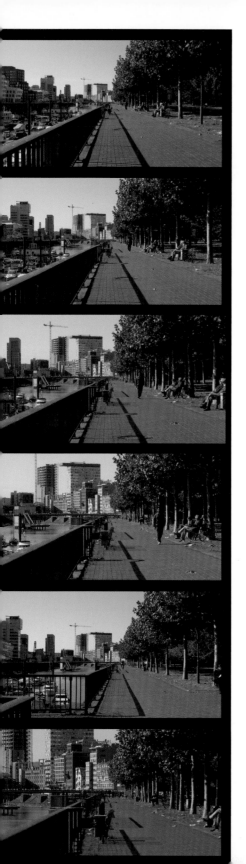

Zooming in on distant objects

A single telephoto image doesn't realistically reproduce the observer's view of this harbor scene. The overall impression of the location can be more effectively captured with a zoomed or tracked video shot.

The zoomed shot (shown in the film strip on the left) and the tracked shot (shown opposite) were shot using different focal length lenses (36-150mm for the zoom, and 50mm for the track), and have very different perspectives as a result. The final image on the left clearly shows the compression effect produced by the telephoto setting.

constantly changing perspective. A dolly shot is often more interesting than a straight zoom, and is an effective way to retain the viewer's attention.

Capturing Movement

Moving subjects are difficult to capture photographically, although image sequences and multiple (or timed) exposures can produce effective results.

Using video to capture movement is the obvious solution, and can be effectively used to reproduce movement in realtime and with a smooth, natural look. Video can also be used to reproduce and study fast movement in slow motion, or to speed up movements that are too slow to follow with the naked eye.

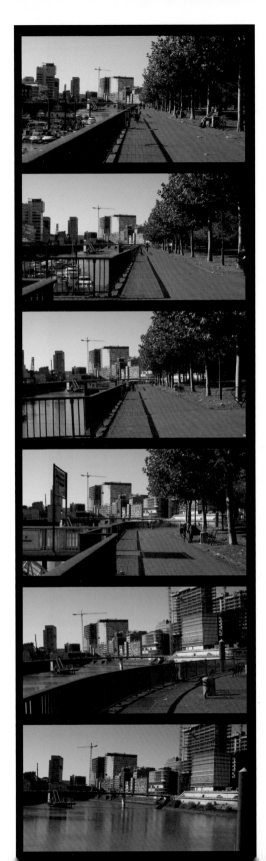

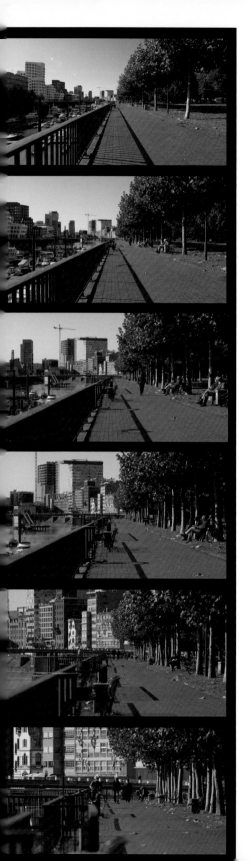

Tips & Tricks: Superzoom effect

You can use multiple zooms with overlapping focal length ranges to simulate a superzoom effect. For example, if you use 16-85mm and 70-300mm zooms for a single shot, you can simulate the effect of an 18x zoom—a lens that simply doesn't exist in the real world. If such a lens were to be built, its range of apertures would certainly be narrower than that covered by the combined lenses.

Superzoom effect

Here, we have extended the zoom range of our previous example using an additional lens. We used two lenses with overlapping focal length ranges to produce an impressive 24-450mm superzoom effect.

Avoiding Errors

Even if everything appears to go smoothly during a shoot, you will often discover mistakes and imperfections when viewing your material at home. Flicker effects or unwanted sudden highlights during pans are good examples of the types of error that show up later. Some artifacts can be conspicuous enough to make your material useless, while others can be corrected (with varying degrees of effort) during post-processing.

Many errors can be avoided if you are aware in advance of the specific risks involved in the type of scene you are filming. You can often use simple measures to avoid making serious mistakes.

Lens Flare

All lenses, including modern, multi-coated ones, produce internal reflections—and thus visible artifacts— when shooting into strong backlight. Modern lenses have up to 12 elements, and some of the light entering the lens is reflected from every internal surface, causing the uncontrolled formation of spots or rings of (often colored) light within the image, called lens flare. The best way to work around lens flare is to avoid having any direct sources of bright light (such as the sun!) within your frame. However, light sources near the edges of the frame can also cause flare, which can best be avoided using either a lens shade or, better still, a compendium or matte box.

Photographers experience the same problems with lens flare, but reflections can be more easily retouched out of a single photo than from an entire video clip. Flare artifacts also change their shape and size during camera movements, making them even more difficult to ignore in the finished sequence.

Flare, however, can also be used deliberately to enhance the aesthetics of a shot, and some image processing programs include tools for the artificial production of flare-like artifacts.

Tips & Tricks

Use test shots whenever possible to check your image quality. If you discover that your shot is not up to scratch while you are still on location you can always reshoot the scene. If, however, you only discover your mistakes during post-processing it is often too late for a retake. Some artifacts are too small to be visible on the camera monitor, so it is best to view your test shots on a notebook computer if possible. This can make shooting more complicated, but definitely involves less work than returning and reshooting later.

Clip: Eib Eibelshäuser

Flare artifacts

Here, the camera was aimed too directly at the sun while shooting, resulting in a whole series of flare artifacts. This scene was obviously shot using a camera with a CMOS sensor—the same shot would have turned out completely unusable if it had been shot with a CCD-based camera.

If you decide to use flare as part of your creative process, try out various lenses before shooting to see which produces the most pleasing results. Every lens has its own flare patterns, and, interestingly, those produced by expensive, highly corrected lenses often look like simple shooting errors. Cheaper lenses often produce flare effects that are complex and really quite beautiful.

Rolling Shutter Effect

We addressed the rolling shutter effect that affects cameras with CMOS sensors in the *Basics* chapter.

You can avoid this effect by either using a camera with a CCD sensor for risky scenes, or simply avoiding shooting scenes in which the effect can appear. Both solutions have advantages and disadvantages. If you use two cameras, you will need to make sure that the color balance and exposure settings for both are as near identical as possible, but you will not have to make any compromises

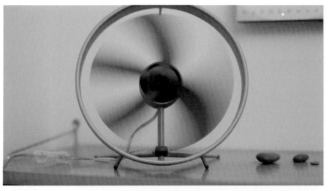

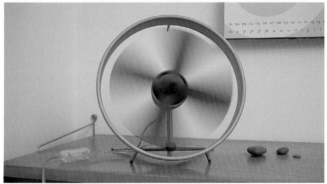

Rolling shutter effect

These two images of a rotating fan clearly show the difference between the effects produced by CMOS- and CCD-based cameras when they are used to film fast-moving subjects.
Top: the CMOS sensor produces an obvious rolling shutter effect, causing the fan blades to appear curved.
Bottom: the CCD sensor produces a natural-looking image.

regarding your choice of location or subject. If you don't have an additional CCD-based camera, it is best to avoid fast-moving subjects such as trains, cars, or ventilation fans altogether.

Moiré Effect

Some camera sensors react badly when filming tessellated patterns and textures such as brick walls, fences, printed pictures, or clothing fabrics. The resulting effect is called moiré, and produces visible subpatterns within the texture of the object.

Clip: Eib Eibelshäuser

Moiré effect

It is critical to avoid moiré effects are critical in important image elements or where they cannot be excluded from the main focus area.

While moiré effects affect only fixed, repeated patterns in photographs, they can appear animated in video sequences, making them even more obvious to the viewer. Moiré effects are just as likely to appear in clips shot using CMOS or CCD sensors.

The best way to avoid moiré effects is to leave moiré-producing objects out of your shot. Fine-checked sports jackets are guaranteed to drive even experienced camera operators crazy, as they simply cannot be filmed without producing moiré artifacts. Fences and brick walls in the background of a scene can also produce moiré effects, but these can also be avoided if the offending objects are kept deliberately out of focus.

Blooming and Smears

Blooming and smears are artifacts often produced by CCD sensors when they are used to film very bright light sources or reflections. Shots showing these types of errors are usually useless, so (if you are using a CCD-based camera) it is important to check in advance whether the light sources within your shot will overstretch your camera's sensor.

Blooming produces bright, circular halo patterns around highlights, and completely blots out any differentiation in tonal values, leaving the affected area pure white. Smears are bright, vertical stripes that pass through the center of point high-

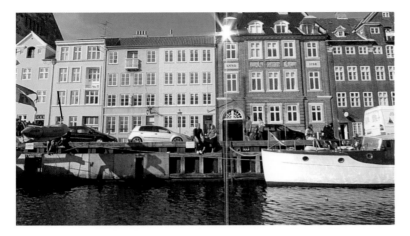

Blooming and Smearing
Although we tried hard to exclude direct sunlight from this
shot, the sunlight reflected from the window directly into the
lens caused simultaneous blooming and smearing during part
of the clip.

lights. These two effects often appear
together.

If you are using a CCD-based cam-
era, you can only avoid blooming and
smears by making absolutely sure
that your shot doesn't contain bright
light sources, including the sun. If it
is not possible to alter the composi-
tion of your shot, you will have to use
a camera with a CMOS sensor.

Specks and Spots
Sooner or later, even the most careful
photographer or filmmaker will have
to deal with dust or water drops on
the lens or dust and fluff on the sen-
sor. The best way to avoid problems
with dirt is regular use of lens cloths

and blower brushes and to treat your
equipment carefully, especially when
changing lenses. Remember to check
the rear lens element for dirt too.

Many DSLRs have built-in sensor-
cleaning mechanisms that use ultra-
sound to "shake" dust off the sensor,
and I can confirm that such systems
seriously reduce the problems caused
by dust on the sensor. It is never-
theless important to change lenses
quickly and carefully, and to hold the
open camera body out of the wind
and weather while doing so. Remem-
ber too, that dust removed by ultra-
sound remains inside the camera and
will re-attach itself to the sensor, the
mirror, or the rear lens element at the

Clip: Eib Eibelshäuser

Spots on the lens

Water drops on the lens are annoying, but often unavoidable, especially where action scenes are involved. Try to get into the habit of checking your lens regularly, as specks and spots on the lens are often very distracting in a finished clip and are virtually impossible to retouch.

next opportunity, making it doubly important to avoid letting dust into the camera body in the first place.

Specks and spots are not necessarily obvious in digital photos and can be relatively easily retouched. Specks in a video are much more conspicuous because they remain static in relation to the rest of the action. It is very important to avoid dirt and dust in your equipment at all times when shooting video, as retouching affected material later is virtually impossible.

Flicker Effects

Flicker effects are also very common in CMOS-based cameras and often appear when the lighting conditions change while the individual lines of a frame are being processed by the camera's firmware. This is always the case where intermittent or predominantly artificial light sources (such as neon light) are involved.

Brightness flicker can only be avoided for CMOS-based cameras if the scene is not lit using artificial light. In contrast to other artifacts, flicker effects are relatively easy to spot on the camera's monitor, especially in Live View mode, where the

Excessive noise

High ISO values have negative effects on video just as they do on photo image quality. Image noise is often more irritating in a video than it is in a photo. The plus side of the story is that using a DSLR allows you to shoot video in what used to be impossibly low light.

low resolution image usually flickers even more than the original scene.

Noise

Noisy video images are simply not nice to look at. Noise (or grain, as it is called in the analog world) can be deliberately used to underscore the authenticity of photographic images, but has no such use in the world of moving pictures.

Although they are the cause of most excess image noise, it is nevertheless tempting to experiment with the high ISO values offered by modern DSLRs. If you do experiment (and I certainly recommend you do), it is

important to remember to reset your ISO value before continuing with the rest of your shoot. If you forget, you will end up with noisy images, even under normal lighting conditions.

You can avoid shooting whole sequences with incorrect sensitivity settings if you simply make it a habit to check all your settings before pressing the shutter button. This also helps to avoid mistakes caused by other user-controlled settings, such as manually selected exposure compensation values, a wide-open aperture, or an exposure mode that is not appropriate to the current situation.

Overexposed sequence
Overexposure is difficult to correct because the over-bright, white areas contain no pixel information that can be tweaked

Under- and Overexposure

Incorrect exposure is the single most common mistake made when shooting photos or video. Photographic exposure is a complex topic in spite of the high-tech metering systems built into modern cameras, and the subject gets even more complicated when shooting video. Unlike in a photo, where the exposure parameters only have to remain perfect for a fraction of a second while the shutter is open, exposure in a video clip can change during the shot. You either need clairvoyant abilities to accurately predict the exposure conditions at the beginning and end of a scene, or you have to ensure that the scene changes in a predictable fashion by taking and evaluating test

Underexposed sequence
Underexposed footage can usually be corrected, as dark
images still contain detail that can be pepped up

Automatic in-camera exposure optimization
Activating exposure optimization helps clips with even a
broad tonal range to turn out well exposed

Manual focusing without tracking
Focus was set to infinity at the start of the clip and wasn't tracked as the boats approached the turning buoy

shots for all phases of the action. In most cases, you should be able to rely on the camera's built-in metering systems to produce acceptable results.

It is easier to avoid potentially non correctable under- or overexposure situations if you know what causes such situations in the first place. Overexposure is generally more critical than underexposure. Lost detail in overexposed highlights remains lost and cannot be retrieved, whereas it is often possible to tease detail out of an underexposed image at the post-processing stage.

Recently, camera manufacturers have begun to build automatic image optimization algorithms into their camera firmware. The Nikon version is called *D-Lighting* and Canon calls its algorithm *Auto Lighting Optimizer*. These tools are fairly good at helping avoid basic exposure errors by ensuring that bright parts of the frame aren't too bright and that darker parts of the image don't disappear into shadow. Both tools alter the range of tonal values in an image in a way that is more similar to the perception of the human eye than the way film material captures light. This is a significant advance in the world of video.

Focusing without Autofocus

Out-of-focus shots are one of the most common causes of unusable footage. Most cameras don't support

Limits of autofocus systems
This is a typical example of the type of foreground to background focus pull that autofocus systems cannot cope with. This type of shot can only be focused manually.

autofocus in video mode, and focusing manually is difficult. Keeping multiple moving subjects in focus is only really possible if you take test shots to predetermine your focus settings. It is also tricky to see whether your scene is properly in focus using just the small camera monitor. Focusing problems are often only visible when viewing footage later on a computer monitor—and then it is probably too late.

For stationary subjects, all you need to do is set focus using autofocus before shooting.

With moving subjects, you need to track focus with the subject, which is difficult (but not impossible) using the focus ring built into the lens. This is easier to do if your lens has an

easily readable distance scale. You can then use test shots to determine which focus settings you need and track focus from one point to the next during the shot using the scale as a reference.

The ideal solution in such situations is the use of a follow focus tool, as described in the *Dedicated Accessories* section of the *Equipment* chapter.

Focusing with Autofocus

Nowadays, it is difficult to imagine photography without autofocus, and modern autofocus systems are generally faster and more accurate than the best professional photographer. The latest DSLRs support autofocus in video mode, but it is important to remember that these systems were developed for photographic use. It is impossible to tell from a photo whether the camera focused directly on the subject or whether it first focused beyond the subject before pulling back to include the desired detail. Again, things are different when you are shooting video, and every lens movement made by an autofocus system is visible in the finished clip. It is simply unacceptable for the viewer if the camera "searches" back and forth for the appropriate focus setting during a shot. This is why professional film cameras do not have autofocus and the camera operator still sets focus manually for every shot.

It is unlikely that autofous systems will be able to deliver satisfactory video results in the foreseeable future. Focus is an important creative tool in the world of moving pictures, and autofocus systems cannot reliably perform even simple tricks, such as shifting focus from one person to another within the frame.

For this reason alone, serious videographers should develop their technique to allow for manual focusing, with or without the help of appropriate accessories.

Automatic Camera Functions

Automatic functions are designed to make life easier, but sometimes cause unnecessary annoyance. Automatic white balance, for example, is a useful tool, but some automatic exposure modes (especially programmed auto modes) can cause serious problems. Programmed exposure modes are designed to help inexperienced photographers to make complex camera adjustments in certain photographic situations, but are not optimized for use when shooting video. Programmed modes often activate Auto ISO or fully automatic exposure control functionality.

It is usually possible to manually adjust all the settings made by programmed modes, and using manual adjustment is the only way to stay in full control of your shoot.

Ultra-wide-angle pan
Take care if you are planning to shoot a pan using an ultra-
wide-angle lens. Such lenses can cause severe distortion in
important elements of the image, especially at the edges of
the frame. These three images are taken from a wide-angle
pan from left to right. The tower is obviously distorted in the
first and last images and, as a consequence, appears to tip
during the clip.

Problem	Cause	Remedy
Lens Flare	Reflections from bright light sources shine directly into the lens	• Avoid bright light sources • Use a lens shade or matte box
Rolling Shutter Effect	Fast, horizontal movements (only for cameras with CMOS sensors)	• Avoid fast, horizontal movements • Use a camera with a CCD sensor
Moiré Effect	Fine or tessellated textures cause interference in the pixel structure of the frame	• Avoid problematic textures • Keep susceptible background textures out of focus
Blooming and Smears	Shooting with extremely bright light sources (only for cameras with CCD sensors)	• Avoid over-bright light sources • Use a lens shade or matte box • Use a camera with a CMOS sensor
Specks/Spots	Dirt or dust on the lens	• Check and clean the lens regularly
Flicker	Intermittent light sources (only for cameras with CMOS sensors)	• Use a different light source • Use a camera with a CCD sensor
Noise	Sensitivity (ISO value) set too high	• Shoot using a lower ISO value • Adjust the lighting
Under- or Overexposure	Incorrect exposure settings	• If in doubt, underexpose • Activate automatic exposure optimization
Focus Errors	• Incorrect manual focusing • Autofocus error • Selected exposure mode adjusts aperture automatically	• Use a lens with a focusing scale • Focus manually • Select the aperture manually (for optimum depth of field)
Distortion	Short focal length lenses often distort at the edges of the frame	• Avoid placing important image elements at the edges of the frame
Camera Shake	• Unwanted camera movements • Environmental vibrations	• Use a tripod • Activate your image stabilizer • Stabilize footage during post-processing

Never use exposure modes (such as shutter-priority or programmed auto) that automatically adjust the aperture while filming. Random changes to the aperture setting during filming can radically change the appearance of your shot. Camera-controlled exposure is always risky, especially when short shutter speeds are selected automatically.

I recommend that you always use manual exposure when shooting video. This way, you can avoid mistakes and simultaneously improve your technique.

Distortion

Every lens has its own distortion characteristics. In a photographic context, distortion is most obvious for geometric subjects, such as buildings. As soon as you shoot a pan, a zoom, or a dolly shot, any lens distortion becomes animated and therefore very obvious. Always use lenses that produce as little distortion as possible.

For example, the pin cushion distortion common in wide-angle lenses can cause a normal-looking object in the center of the frame to become magnified and distorted-looking when it changes its position during a pan. This type of distortion does not equate to a "normal" view and can easily irritate the viewer.

You can work around these effects if you avoid using major camera movements (i.e., tilts, pans, zooms, or tracking shots) while shooting with distortion-producing lenses. Any movement that changes the position of major elements within the frame is risky, especially if you are shooting with a wide-angle or fisheye lens. The need to pan is reduced when using wide-angle lenses anyway and, where a pan is unavoidable, it is always better to use a longer lens.

Distortion can, of course, be used creatively (for dream scenes, for example), but try to avoid using too much distortion when portraying people or faces.

Camera Shake

Camera shake causes photos to appear out of focus, especially if they are shot using long shutter speeds. In a video context, camera shake is doubly obtrusive, as it not only makes the individual frames unsharp, but also reproduces the movement that causes the camera shake itself—definitely a situation to avoid!

The first and most obvious way to avoid camera shake is to use a tripod.

Common image problems: causes and remedies

A tripod can, however, become unreliable if the surface your tripod is standing on is unstable. If you are shooting indoors, check that the floors are solid and that there are no busy streets or railroad tracks near your location. Any or all of these factors can make shooting from a tripod impossible.

The next best way to ensure shake-free footage is to switch on your camera's image stabilizer. If you have a fairly steady hand, you can achieve great results with the help of this simple tool.

The last resort for avoiding shaky images is to use software-based tools to resample your footage. Such tools shift the pixels so that fixed elements in the clip no longer appear to move between frames. Unfortunately, stabilizing footage at the post-processing stage usually involves making a tighter crop and cannot correct out-of-focus effects in individual frames.

Ten Rules for Shooting Better Video

If you want to shoot better videos, you will often have to make difficult choices. The following checklist will help you avoid some of the more common mistakes and also gives a few tips for new techniques to try.

Avoid Unnecessary Zooms

A zoom is not a natural way of viewing a scene, and long zooms generally distract the viewer more than they enhance the action. A dolly or tracking shot is often more natural-looking and less confusing for the viewer. Zooms are nevertheless an effective stylistic device if used carefully.

Avoid Unnecessary Pans

Pans appear natural to us, as they are an integral part of the way we view the world. We can easily turn our head (or our entire body) in order to view a different part of a scene. Too many pans, or pans that are executed too quickly, can have an unsettling effect. The old adage "less is more" applies to all film effects. Excessive use of effects often creates the opposite effect to the one the filmmaker is trying to achieve.

Avoid Unnecessary Changes in Focal Length

It is important to stick to a single focal length when making reverse angle shots. Most film textbooks only warn you not to cross the imaginary line of the narrator's point of view so as not to unintentionally alter the direction of the protagonists' view. It is just as important to retain the same perspective during such sequences. A change of focal length during a reverse angle dialog makes the distance between the protagonists appear to change, resulting in an unrealistic-looking scene.

Use an Appropriate Lens

Standard, wide-angle, and telephoto lenses have obviously different effects on the perspective of a video image, and should always be used carefully in order to underscore the intention of a scene. A wide-angle lens simply cannot be used to condense distance, and a telephoto lens will always make objects appear closer together.

Use Depth of Field Creatively

Opposites create interest. In-focus and out-of-focus effects are great stylistic devices, and should be used deliberately but sparingly when shooting video. Shallow depth of field can be achieved not only using large image sensors, but also by using larger apertures.

Tips & Tricks: Soft zooming

An extreme slow-motion zoom can be used creatively to gain the viewer's attention without making her aware that a zoom is actually taking place. A subtle, well-executed zoom is felt rather than seen.

Tips & Tricks: Panned dolly shot

Don't be afraid to experiment with combined effects. A simultaneous slow pan/dolly shot that keeps the main subject in the center of the frame can produce an image that actually appears calmer than a static image.

Careful with that zoom!

If you are shooting dialogs (or any other reverse angle sequence), make sure the position of your zoom ring cannot be accidentally changed from shot to shot.

Know Your Sensor

The two most common types of DSLR image sensor (CCD and CMOS) behave differently in various situations, and both have very specific advantages and disadvantages. Learn to use your camera's strengths creatively and to avoid situations that expose its weaknesses.

Stay in Control

Automation is good, but manual control is better. Even if your camera supports autofocus in video mode, it is seldom effective. Autofocus can be used to aid focusing before shooting for scenes that don't involve focus pulls, but is almost useless for scenes with changing focus. Today's autofocus systems are not designed for use in a video context and usually function too quickly, focusing beyond the actual subject before "settling down". These characteristics are not suitable for video use and create unrest in the finished clip.

Avoid Using too much Fast Movement

Even though we are used to fast action in movies, computer games, and music videos, pans or zooms that are executed too quickly still irritate the viewer. It is important to begin and end every camera or lens movement slowly and smoothly. Jerky movements are generally taboo for video shoots and, as a rule, slow is usually better than fast.

Always Shoot Using the Best Possible Image Quality

It is virtually impossible to improve image quality once footage has been shot. Always use the highest possible resolution and the greatest possible frame rate. You can always resample to lower values later if necessary. Your camera's highest resolution does not, however, always produce the best quality images—a higher frame rate at a lower resolution is always preferable when it comes to producing the best overall image quality. In other words, shooting HD video at 30 fps is better than shooting Full HD at 20 fps.

Learn from Your Mistakes

Practice makes perfect and, so the saying goes, "The proof of the pudding is in the eating". This may sound like a worn-out cliché, but is well suited to the intention of this book. You can only learn to make great video by shooting video. Whether it turns out successfully or not, every project broadens your experience—and there's no substitute for experience …

Legal Issues

As well as logistical, technical, and artistic issues, you will nearly always have to deal with some legal issues when shooting video. It is always necessary to get permission before filming people or on private land. Filming itself is not the problem, but rather public release of filmed material. Getting permission after the event is often difficult and sometimes impossible, so it is always better to deal with permissions before you start shooting.

It is not always necessary to get written permission to shoot, but where money changes hands it is usually advisable to use a written contract, if only for tax reasons.

It is not always obvious to outsiders that you are filming, especially when you are using a DSLR. You need to be sensitive to people's feelings and expectations, and you should always get permission (if necessary, after you have finished shooting) if you think that any of your subjects are not aware they are being filmed.

Personal rights, usage rights, and copyright are complex subjects, and should be dealt with by legal professionals, especially if you are shooting film commercially. Getting proper advice can save a lot of hassle when formulating permissions and other contracts, and if you are well informed of the legal situation, you can react appropriately if you are involved in any disputes on location.

The following sections are intended to raise your awareness of the legal practicalities when shooting video. Everyone who takes photos or shoots video for public viewing should be aware that he/she can be prosecuted for wrongful broadcast or violation of third party rights that broadcast or publication may cause. Remember, a court case can easily cost more than a whole new set of high-end camera gear.

Filming People
People are the automatic owners of the rights to their own image. Some societies also see this right as ethically, morally, religiously, or culturally based, and filming without permission in such countries can have drastic consequences that are not only of a legal nature.

Most importantly, any person being filmed should know how and where their image is to be published. For example, it can be a lot easier to get permission to show a person's image in a film intended for one-off broadcast on TV than for a feature that is to be published for an indefinite period of time on the Internet.

A subject can give permission to film tacitly by waving directly into the camera, orally by speaking into

the camera while sound is being recorded, or, if you want to be absolutely sure of your ground, in writing.

Filming Children

In many countries, children have special rights, and you should be aware of these while filming. Make absolutely sure that the parents or guardians of the children you are filming have given their permission. Respectable TV stations, advertising agencies, and marketing companies will only accept film of children if all permissions are delivered with the material. A violation of children's rights is always considered a more serious misdemeanor than violation of adult rights.

Celebrities and Other Media Personalities

There are limits to the personal rights of celebrities, making it easier to film well-known personalities without first getting permission. Celebrities can be filmed without permission if they do not feel their basic human dignity is endangered—a right that is not always observed by the paparazzi. People in the news are generally divided into two categories. The first is those who are, by the nature of their work, in public service and constantly in the public eye, such as politicians or members of royal families. The second type are people who only indirectly receive public attention,

such as sports stars, actors, participants at public events, and (macabre though it may seem) victims of accidents and natural catastrophes. Generally, if material showing these types of people serves the public interest, you do not need to get special permission to shoot.

Getting Permission to Shoot on Location

Private property is also protected by law, and you will need to get permission to include it in your shoot. Shooting inside public buildings (such as museums or government agencies) also requires permission.

If you are trying to get permission to film in or at a private company, the legal department will often want to know when and how the finished material will be broadcast. This can take some time, so make sure you plan sufficient time into your preshoot schedule. Getting the right permission in advance can often save you being thrown off location while filming.

Filming Products

The props and incidental objects that appear either intentionally or accidentally in your videos are also subject to copyright law, especially where brand names are concerned. As long as products only appear in the background, they usually present no problems, and can even be used

intentionally as part of a product placement scheme. If copyrighted brand names appear as an identifiable part of the action (especially if the context could be construed as negative), it is usually advisable to blank out the product's name.

Sound

by Helmut Kraus

Sound is an important part of any film, and professional sound recordists often swear that "The sound makes the picture". A simple experiment helps to show how true this is: simply turn down the sound during an action film and see how exciting the silent pictures appear. The opposite is also true, and modern surround sound systems can give even average movies a real "edge". Sound intensifies the visual experience and high quality sound often directly improves the quality of the pictures.

Sound is a complex subject that, in itself, goes way beyond the scope of this book. A sound specialist for miking, recording, and processing sound is vital to the success of any professional film project. Simultaneously shooting film and recording sound is only possible in a limited way and, just as good sound enhances your pictures, bad sound can reduce the overall quality of otherwise great film material.

It is nevertheless common practice for photographers to act as their own sound recordist. Modern, video-capable stills cameras increase the pressure on photographers to record sound and video, especially in a reportage context. At the end of the day, a photo team is cheaper to send on location than a film team.

So, if you intend to get into shooting video with your DSLR, it is a good idea to spend some time familiarizing yourself with sound recording techniques too—even if this only means that you better understand your sound recordist's job.

"Normal" sound recordings made with a DSLR are usually pretty bad. Dialog recorded using the camera's built-in microphone will usually be full of distracting ambient noise. Human hearing is extremely highly developed and is controlled by many more neurological optimization processes in the brain than human eyesight. The brain constantly suppresses background noise in order to filter out important sounds, whereas a microphone simply records everything within range. The human brain can, however, only differentiate sound in the real world. If we listen to recorded sound, the lack of spatial differences between sound sources makes it impossible for us to filter out background noise in the normal way. It is therefore extremely important to use the right microphone to record only the relevant sounds from the best possible position within your scene.

Microphones

All video-capable DSLRs have a built-in microphone that records sound directly as part of the video file. Unfortunately, none of the currently available built-in microphones record sound of a quality that does justice to the fantastic images a DSLR can produce. This is because a built-in microphone always picks up mechanical camera noise (autofocus and image stabilizing systems, etc.) and because it has to be small (and therefore low-quality) to fit into the camera body.

If you delve deeper into the subject of film sound, you will quickly realize that the camera's built-in microphone is in the wrong place for most of the purposes it was designed to fulfill. The conditions necessary for recording satisfactory sound are different from those required to record great images. Sound can "see round" obstacles and will record all sounds produced by the subject, whether it is visible in the shot or not. The camera itself is never in an optimum position for recording location sound and if you want to use live sound material, you will need to use an accessory microphone or separate recording gear.

Built-in Microphones
You cannot influence the type or specifications of your camera's built-in microphone. Camera manufacturers usually use simple electret microphones and don't bother to list the precise specifications in the camera manual. It is not usually possible to adjust sound volume, levels, or dynamics while filming.

Location sound recorded using the camera's built-in microphone is nevertheless useful for checking synchronization when you are mixing separately recorded sounds into the soundtrack or replacing the live track with recorded material later on.

If your camera has no accessory microphone socket you will either have to do without location sound altogether or resort to using a separate recording device.

Accessory Microphones
Accessory microphones can be attached either directly to the camera or to a separate sound recording device. A microphone attached to the camera will help you produce better sound quality, but will still not allow you to influence the volume or dynamics of your soundtrack.

Recording sound separately is always the best way to capture location sound, but requires the use of additional equipment and, usually, an additional member of the team. Shooting video is a complicated process and it is not realistic to expect the photographer/camera operator to record his or her own sound too.

Photo: Canon

Built-in microphone
Typical position of a
built-in DSLR micro-
phone

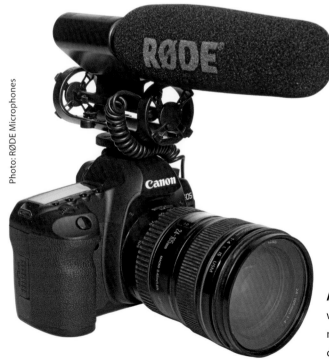

Photo: RØDE Microphones

Accessory microphone
with an anti-shock
mount attached to the
camera's accessory shoe

Microphone Technology

Built-in and accessory microphones use various technologies to convert sound waves into electrical signals. The following sections describe the three most common microphone types and the ways they work.

Dynamic Microphones

Dynamic microphones are simple and tough, and are often used in loud situations in order to avoid producing distortion for peaks in sound levels. They are, however, less suited for recording quiet sounds. Different dynamic microphones have varying ranges of sensitivity, but they are generally accepted as having a timbre that is better suited to recording specific sound sources (such as musical instruments) than to capturing general on-set sound. Dynamic microphones do not have their own power source.

Condenser Microphones

Condenser microphones require separate power, either from a battery or via a cable attached to a mixing desk. They generally produce a more balanced sound and have a greater frequency range than dynamic microphones. However, their greater sensitivity makes them more susceptible to interference and background noise, such as wind. A condenser microphone is also more likely to produce distortion when recording loud noises.

Electret Microphones

Electret microphones use the same type of transducer as condenser microphones. Their compact dimensions, low power requirements, and comparatively good sound reproduction characteristics make them the best choice for use in mobile devices such as telephones, headsets, and cameras.

Mono and Stereo Microphones

Most types of microphone are also available in mono and stereo versions. Stereo microphones actually consist of two separate microphones mounted so that they split sound coming from different directions and record it on separate channels. Not all built-in camera microphones are stereo.

Directionality

The most important feature of a microphone is its directionality, which describes its sensitivity in relation to the angle of incidence of the sound waves it is recording. Even the most expensive high-end microphone can be useless in a particular situation if its directionality is inappropriate, and it is important to understand the directional properties of a microphone in order to use it effectively.

Dynamic microphone

Dynamic microphones function like a kind of reverse loudspeaker and convert sound into electrical signals without the application of external power. They are best used in loud situations and are not suitable for recording quiet sounds.

Condenser microphone

Condenser microphones produce more balanced sound than dynamic microphones but are more susceptible to interference such as wind noise. They tend to distort louder sounds.

There are three main types of directionality: omnidirectional, unidirectional, and bidirectional. Omnidirectional microphones record sound coming from all directions with equal sensitivity, whereas bidirectional microphones usually emphasize sound coming from in front and from behind. A unidirectional microphone usually only records sound coming from the front and, if at all, captures other sounds muted.

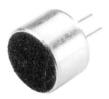

Electret microphone

Many DSLRs have tiny, built-in electret microhpones

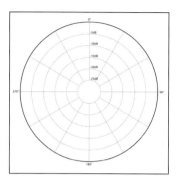

Omnidirectional

Subcardioid

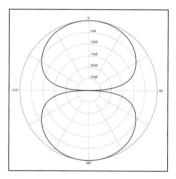

Bidirectional

Cardioid

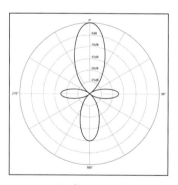

Unidirectional

Supercardioid

Directional properties of microphones

The polar diagrams reproduced here describe the most common types sound recording microphone directionality. These directional properties are dependent on the shape of the microphone capsule as well as the characteristics of the microphone body (spherical, shotgun, blimp etc.).

Hypercardioid

Illustrations: Wikipedia, Galak76

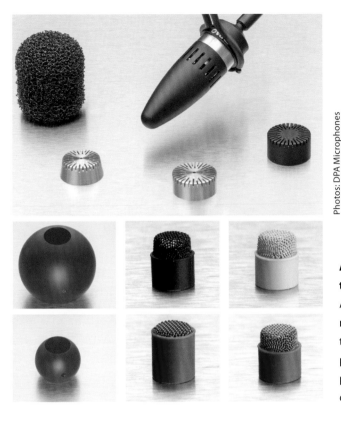

Adjusting directionality

Add-on accessories make it possible to tailor a microphone's directional properties to a specific application

There are also several subtypes of microphone available, called subcardioid, cardioid, supercardioid, and hypercardioid.

Directionality is not dependent on the type of transducer built into a microphone but rather on its overall construction. It is possible to adjust a microphone's directionality using add-on accessories.

Microphone Accessories

Just like film gear, sound recording equipment depends on the use of accessories to make life easier. The following sections describe a few of the more useful and important microphone accessories.

Windshields

A windshield is the single most important microphone accessory. Most microphones are equipped with metal or plastic mesh covers

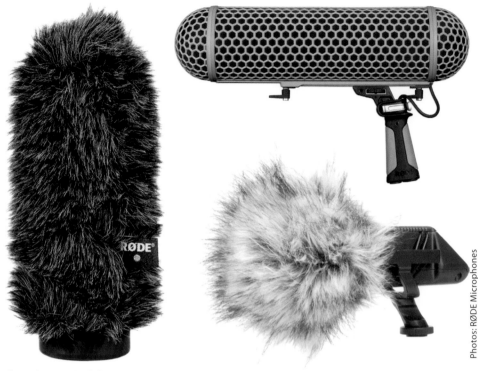

Photos: RØDE Microphones

Microphone windshields
Various types of windshield are available for reducing wind
and other types of atmospheric background noise

to protect the membrane, and these also provide a small amount of protection from wind noise. The most effective windshields are made of real or fake fur and prevent all types of excess air turbulence noise. Fur windshields are often referred to as "dead cats", "poodles", or "windjammers". In less sensitive situations (indoors, for example) a simple foam windshield will prevent the noise caused by the microphone moving through the air.

Suspension Units
The connection between a microphone and a camera/tripod assembly should always be elastic in order to prevent noise caused by tripod jarring. This is especially true of accessory microphones attached to the camera, and such microphones should always be rubber mounted. Rubber anti-shock mounts also prevent noise from the camera's internal autofocus and image stabilizing

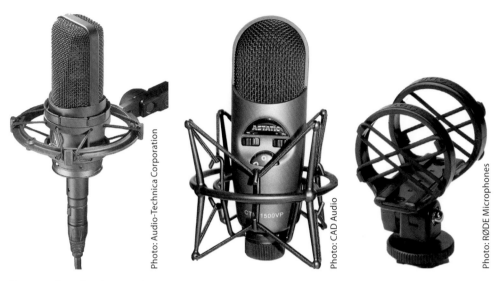

Photo: Audio-Technica Corporation

Photo: CAD Audio

Photo: RØDE Microphones

Suspension shock mounts

Some of the many types of suspension mounts available:
Here, the microphone is suspended in a rubber harness
and can vibrate freely, making it less susceptible to jolt
and vibration noise.

Microphone boom

Booms are used to position the microphone nearer the
action while ensuring that the sound recordist doesn't
appear in the picture

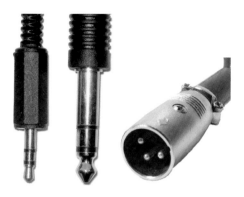

Microphone plug types

3.5 mm jack, 6.35 mm (1/4-inch) jack,
XLR connector

Jack plug adapters

Adapters can be used to step the size of your
microphone jack up or down

systems from being picked up and
recorded by the microphone.

Booms and poles

A telescopic boom is the most impor-
tant type of microphone mount for
video use. This relatively simple tool
allows the sound recordist to posi-
tion the microphone near to the per-
son speaking while ensuring that nei-
ther he nor the microphone appears
in the frame.

Plugs and Adapters

All accessory microphones have to be
connected to the camera or recording
device, usually (with the exception
of radio microphones) using a cable
and plug. A 3.5cmm jack socket is the
most common type of connection
built into DSLRs, while many high-

end microphones use the larger 6.35
mm (1/4-inch) jack type.

In practice, it is unimportant which
type of plug or socket your camera or
microphone has, as there are simple
adapters available for both sizes of
plug and socket.

Professional microphones and
recording devices are generally built
around the XLR-type plug system.

Headphones

You can only effectively set the lev-
els for separately recorded sound
using closed-back headphones. Your
headphones must cut out all ambi-
ent noise in order for you to be able
to hear and assess your soundtrack
properly. Open headphones or ear-
buds like those bundled with most
MP3 players are not suitable for film
work.

Avoiding Background Noise

A large part of a sound engineer's
work involves avoiding or eliminat-
ing background noise. The following
sections will help you to identify and
avoid common sources of unwanted
noise.

Hum

Humming sounds are usually caused
by electrical transformers or other
types of control unit. The power units
for the HMI lights used on film sets
are often the cause of microphone
hum. The best way to avoid hum is to
ensure that the microphone is suffi-
ciently far away from any power units
and to use a separate power supply
for your sound equipment.

Clicking

Audible clicks are usually the result
of faulty audio cable connections
and this is the first thing you should
check when click sounds appear.
Check your microphone cable for
kinks or breaks too. Click interfer-
ence most often appears after short
breaks in the power supply.

Hiss

Every digital photographer knows
the image noise that results when
the sensor's sensitivity (ISO) setting
is set too high. The same phenom-
enon applies to the transducers built
into microphones, which produce

Photo: Sennheiser

Closed-back headphones
Always used closed-back headphones
when recording location sound

interference when the signal-to-
noise ratio gets too high. This will be
the case if you try to record a sound
that is too quiet at too great a dis-
tance with your microphone's sensi-
tivity level turned up too high. Such
a setup would still generate audible
noise, even if you were to record
silence.

Camera Noise

If you are using your camera's built-in
microphone, the only way to avoid
recording the noises made by the

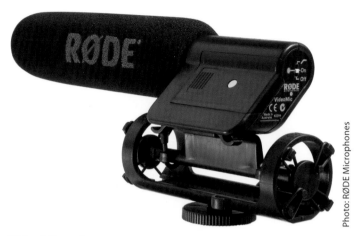

Photo: RØDE Microphones

Video Microphone

This battery-powered video microphone is mounted on a special shock-absorber on the camera's accessory shoe and is connected to the camera's accessory microphone socket (see also the illustration above of the same microphone mounted on a camera)

autofocus and image stabilizing systems is to switch them off. If you are using a camera-mounted accessory microphone, a rubber shock mount will help to reduce or eliminate camera-generated noise. The most effective way to eliminate camera noise is to use a separate microphone and recording device positioned at sufficient distance from the camera.

Wind Noise

Even the slightest breeze or microphone movement can produce audible interference on your soundtrack. The best way to combat wind noise is using a fur (or fake fur) windjammer.

Echo

Audible echo is a sign of an incorrect microphone sensitivity setting that allows the microphone to record not only nearby sounds (such as a conversation) but also the echoes the sounds themselves produce. You can eliminate echo effects by positioning your microphone nearer to the sound source and by reducing the sensitivity level.

Whistle

Whistling sounds are usually produced by feedback. Feedback occurs when the sounds being recorded are also being played back in real time

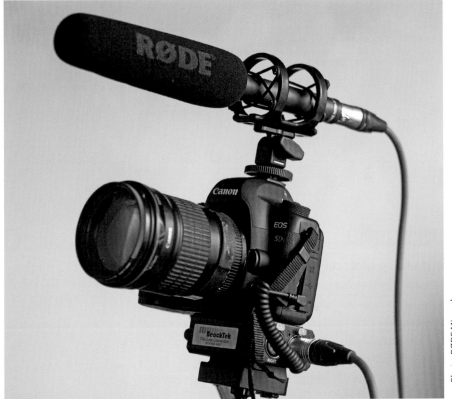

Photo: RØDE Microphones

Dedicated DLSR sound accessories

A DSLR equipped like the one in this picture allows you to record high-quality location sound without the assistance of a sound recordist. A high-end directional microphone with an anti-shock mount and a foam windshield is mounted on the camera's accessory shoe. The sound level is adjusted using an external XLR adapter mounted directly beneath the camera.

through loudspeakers. The playback sound is then also picked by the microphone, causing phase shifts in the sound waves reaching the membrane, resulting in an undulating whistling sound. Feedback is best avoided by reducing loudspeaker volume or microphone sensitivity.

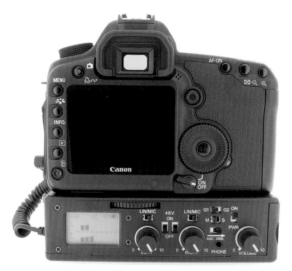

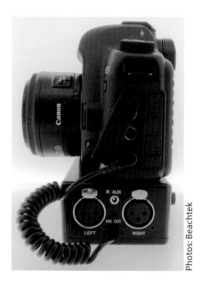

Photos: Beachtek

XLR adapter for DSLRs

The signal processing functions of an XLR adapter enhance your camera's sound recording capabilities enormously. The adapter is mounted directly on the tripod and is connected to the camera using a 3.5 mm jack. You can then use high-end XLR microphones to record your sound. XLR adapters also have a headphone socket for monitoring sound during shooting.

Unintentionally Swapped Stereo Channels

It is important to check the orientation of stereo microphones. If a stereo microphone is held the wrong way round, sounds coming from the left will appear to come from the right (and vice versa) in the final soundtrack. If you should make this mistake, it is usually possible to correct it during post-processing.

The situation is more complicated if you unintentionally hold a stereo microphone at 90 degrees to its intended orientation. This results in sounds coming from above being reproduced in the left channel, while sounds that come from below are reproduced on the right (or vice versa). This produces an unnatural-sounding audio track that can seriously detract from the quality of the finished film, and that cannot be corrected later.

Dedicated Microphone Accessories for DSLRs

Microphone accessory manufacturers have been quick to adapt to the market and are already producing dedicated accessories for use when shooting video with a DSLR. Various video microphones are available with shock mounts specifically designed for mounting on camera accessory shoes, and often have built-in power supplies.

A user-controlled XLR adapter is a good alternative to using a separate sound recording device. Such adapters can be directly attached to the tripod mount and are connected to the camera's microphone socket using a 3.5 mm jack cable. Use of an adapter makes it possible to record your sound using a high-end XLR microphone, complete with level adjustment, level meter, and a volume-adjustable headphone socket for monitoring sound during recording.

Some DSLRs have built-in automatic gain control, which increases the microphone level if the overall sound level is too quiet. The resulting increase in microphone sensitivity often causes excess background noise. XLR adapters use an additional, inaudible signal to fool the camera into thinking the ambient sound level is higher than it actually is, thus circumventing the (often unwanted) auto gain feature.

Four Basic Rules for Capturing Great Sound

DSLRs produce very high quality images but, unfortunately, only low-quality sound. Ideally, you should use a separate sound recording device and employ the services of a sound recordist if you want to do justice to the quality of your images. The following rules are intended to help you avoid the most common mistakes and to produce great sounding video.

Leave Microphone Setup, Sound Recording, and Post-processing to Specialists

If you are in a position to follow this rule, nothing can really go wrong, and the other rules will be followed automatically. We assume that you are reading this book because you are already an experienced photographer and/or filmmaker. If, however, you have doubts about your audio abilities, you should leave sound recording to specialists—a dialog between two specialists usually leads to better overall results.

Always Record Location Sound

Even if you are using high-quality gear to record sound separately, you should always record live sound directly using either the camera's built-in microphone or a shock mounted microphone attached to the camera's accessory shoe. The

resulting video files will not be significantly larger, but the location sound track will make it much easier to dub and synchronize your soundtrack later.

You can also use in-camera sound to record comments, the names of the people being filmed, or details of the equipment being used.

Always Record Sound at the Best Available Quality

If you have the choice between mono and stereo, low and high sampling rates, built-in or accessory microphones, or direct or remote sound recording, you should always choose the better quality alternative.

Avoid Background Noise Whenever Possible

Choose the audio characteristics of your location with the same degree of care you apply to choosing the visual aspects of your shot. Sporadic background noise caused by passing cars, trains or airplanes, or church bells ringing (to name just a few examples) can make a shot useless.

Tiny details make a difference too. A ticking watch too near the camera, or a carelessly held microphone, can also significantly reduce the overall quality of your results.

Dubbing Sound

After all that sobering information regarding the potential pitfalls of recording sound with a DSLR, most readers will probably decide that dubbing sound is probably a more realistic approach. However, this doesn't mean that you have to produce your entire soundtrack in a studio. A music soundtrack mixed with location sound clips can be a very effective tool for small-scale video productions, especially for landscape-based subjects.

Atmospheric sounds don't have to come from the original scene. Prerecorded screeching gull and breaking wave sounds can improve the overall effect of a beach scene enormously. There is a huge range of sounds available either on the Internet or on CD/DVD.

Swapping out location sound for third-party sounds or music takes place during post-processing using an editing program. We will address this subject in detail in the chapter *Editing and Post-processing*.

Location sound recorded using a separate recording device also has to be mixed into the video file using an editing program. The most difficult part of this job is synchronizing sound and visuals. Unlike sound recorded directly by the camera, separately recorded sound has to be synchronized manually.

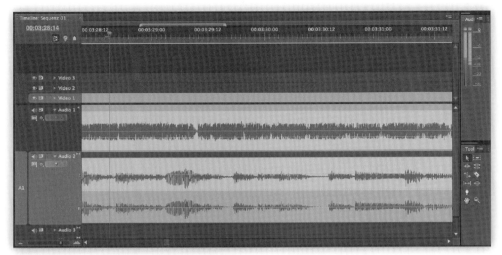

Sound files loaded into an audio editing program

This screenshot of an Adobe Premiere CS4 audio editing window shows the mono location sound recorded by the camera (top) and the dual stereophonic tracks of the musical accompaniment

Photo: Zoom Corporation

You should also be aware of the potential legal issues involved in dubbing third-party sounds. Like visual images, music is also covered by copyright law. If you are using a music soundtrack, you should check first whether the music you want to use is subject to copyright fees and, if necessary, sign a contract with the owners of the copyright.

Nowadays, there is a lot of copyright-free music available on CD or on the Internet for use in film productions.

Recording sound separately

Most digital sound recording devices record sound as MP3 files, which can then be transferred to a computer via USB or memory card. Separately recorded sound has to be manually synchronized with the appropriate pictures.

Editing and Post-Processing

by Helmut Kraus

"The real work starts once the camera work is done." This maxim is true for stills photography and especially relevant when you are shooting video. Freshly shot video cannot be directly presented. In addition to the usual corrections to exposure, color, and sharpness a photographer makes, a video-maker also has to edit her material in order to turn it into a finished, viewable film.

Prior to editing, the raw footage has to be viewed and evaluated, and the reject material separated from the rest. The post-processing workflow for a video shoot is basically always the same:

Step 1: View and Evaluate

First, you need to view your raw footage. If you have already checked your shot on the camera monitor, you will know if it has turned out OK, but you will only be able to tell if a take is really excellent on a large (if possible, calibrated) monitor. It is best to view your material on a desktop monitor.

Adobe Bridge is a great tool for viewing video, and digital photographers who use Adobe Photoshop for image processing will already have Bridge installed. Evaluation takes place using a system of one to five stars that can be applied to files in direct relation to their quality. Zero stars usually means "trash". Bridge is not only great for evaluating footage, but can also be used for adding keywords to video files. Keywords can also be arranged in subgroups, for example: the group "Locations" can also contain the subgroups "Baltic Sea", "Mediterranean Sea", and "Atlantic Ocean". Careful application of keywords and keyword groups makes finding files later child's play.

Step 2: Optimize

Video files sometimes have to be converted before being optimized. For example, if your camera produces AVI files and you want to use Adobe Premiere to edit your material, you will first have to convert your files to MOV format. You can do this quickly and easily using QuickTime.

Once all your files are available in the correct format, you can optimize image quality. Exposure compensation, white balance, and sharpness control are the most common optimization steps.

Step 3: Creating Your Sequence

A sequence has to be prepared before the actual editing can take place. The first step is to organize the individual shots in the order they are to appear in the finished film. Here it is important to check that the events in the film are chronologically organized in order to preserve continuity in the finished sequence.

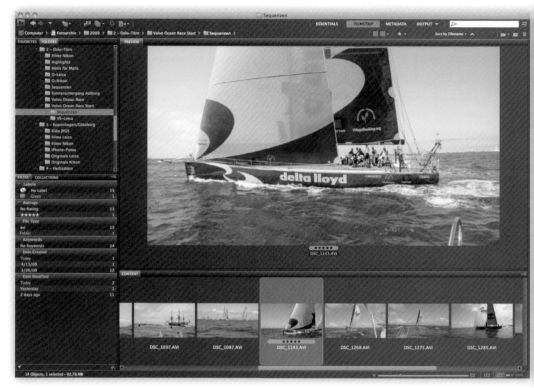

Viewing and evaluating

Adobe Bridge is bundled with Photoshop and Premiere Pro and is a
great tool for sorting, viewing, and evaluating your footage

Step 4: Transitions

The transitions and fades between
shots give the roughly edited
sequence palpable form. Modern
editing programs offer a whole range
of transitions, from classic fades to
complex three-dimensional digital
effects. You can also create your own
fade effects, but built-in effects are
usually easier to apply. All you have
to do is select your effect and choose
its length—the resulting dissolve is
completely predefined.

Step 5: Editing and Adding Sound

Once you have finished editing your
visuals, you will need to edit your
sound. Here, you can use location
sound, dubbed sounds from third-
party sources, or music to enhance
the visual effect of your film.

Step 6: Finishing

The final steps involve correcting color and exposure errors and inconsistencies that only become apparent once editing is complete. You will also need to add titles and credits. Once you have completed your editing, the finished film has to be rendered into a single master file. This can take some time, depending on the program you are using and the processing power of your computer. A ten-minute full HD film consists of 14,000 individual 2-megapixel frames (i.e., about 30GB of data). Rendering can take hours, even using a fast, modern computer.

Mac OS and Windows

Every digital filmmaker has to decide (at the latest, once post-processing begins) which operating system he is going to use. Which is better—Mac or PC? Although this debate has been raging since the first Macintosh was introduced in 1984, the system you use for your digital image processing is largely a matter of personal taste. There are very few hard facts that speak for one system in preference to the other. Professional photographers, musicians, and filmmakers all over the world use both systems (sometimes even in parallel) in order to benefit from the advantages of both. At the end of the day, the software available for each system is a far

more critical factor than the actual hardware or operating system itself.

Adobe releases largely identical versions of all its major programs for both systems, and it generally doesn't matter to an Adobe user which system he uses.

However, the digital photographic world is full of niche software developers who only work on one platform. Here, Windows has the upper hand, although it is also important to differentiate between Windows version compatibilities. Not all XP-compatible programs work on Vista or Windows 7, and vice versa. Mac programs are generally less subject to compatibility problems, and there are very few known inconsistencies between the Tiger, Leopard, and Snow Leopard versions of the system currently in use.

Apple offers three different Mac-compatible editing products for low, middle, and high-end applications (and budgets). All three have a very smooth user interface, as you would expect from Apple.

Apple iMovie (Part of the iLife 09 suite)	Apple Final Cut Express 4.0	Apple Final Cut Studio 7	Adobe Premiere Elements	Adobe Premiere Pro CS4	MAGIX Video deluxe 16 Premium
www.apple.com			www.adobe.com		www.magix.com
$79	$199	$999	$100	$799	$90

Video editing software

The table lists a number of HD-compatible video editing software programs among the many currently available. The list does not represent any value judgements and the prices listed are only intended as a guide.

Editing Software (iMovie & Co)

Apart from the camera, editing software is your most important tool for making HD videos. While digital photographers can, if necessary, work without image processing software, every filmmaker needs editing software to convert his raw material into a finished film.

Photographers who recently switched to the digital medium will still remember their first attempts to get to grips with Photoshop, and beginners who have no analog experience also know just how complex image processing can be. Once you delve into the subject of video and video editing, you will find that editing software works in a very different way to photo processing programs, due largely to the additional time element involved in shooting moving pictures. Every photographer who is

Pinnacle Studio HD	Pinnacle Studio Ultimate Collection	Sony Vegas Movie Studio 9 Platinum Pro	Sony Vegas Pro 9	Cyberlink PowerDirector 8 Deluxe	Corel VideoStudio Pro X2
www.pinnaclesys.com		www. sonycreativesoftware.com		www. cyberlink.com	www. corel.com
$50.00	$130	$100	$600	$90	$100

starting out in the wonderful world of video should be prepared for a steep learning curve when it comes to getting familiar with the special logic of editing software. There are entire books dedicated to each of the programs mentioned, and the scope of this book only serves to give a halfway comprehensive overview of the functionality offered by modern editing software. This chapter is written without reference to a specific program and deals with general functionality that is available in virtually every program of this type.

Editing software is available in every imaginable category of price and complexity. Even if you are tempted to try and save a little of the money you splurged on hardware when purchasing your software, a more expensive package from a well-known manufacturer is often a better long-term investment. Only software that is continually developed to keep pace with the hardware market ensures that you can continue to use familiar tools, even if you change your camera system. We are assuming that the software packages listed in the table will continue to be developed. They have all been around for a while and are all updated regularly.

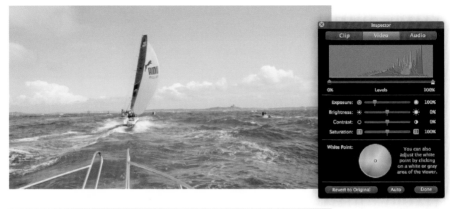

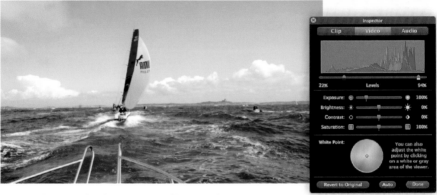

Correcting tonal values using editing software
The correction tools built into most editing programs are very
similar to those found in photographic image processing
software. The images above show an excerpt from a video clip
before and after an automatic tonal value correction, as well as
the corresponding software dialog and histograms.

Preparing Your Material

Once you have shot, reviewed, and
selected your material, you still need
to prepare it for final editing. You will
often need to make corrections to
color, exposure, sharpness, or other
image artifacts before you actually

edit your film. The following sections
deal with the most common steps
involved when preparing video foot-
age for editing.

The most important steps involve
making corrections to color and
exposure and even the most carefully
shot footage can be improved at this

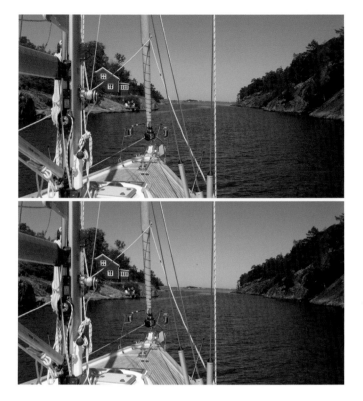

Exposure compensation
This slightly underexposed clip was improved by applying an exposure compensation value of + 1 EV

stage. The correction tools available to filmmakers are largely the same as those used by photographers, with the exception of the ability to shoot and process in RAW mode. RAW functionality is not currently available for digital video.

If you are correcting color and exposure, the pre-programmed tools built into many editing suites are a good starting point. Simply apply a standard tool to your material to see if you can detect an improvement before you get into making complex corrections of your own. Corrections

to white balance, exposure, and highlights and shadows detail also often improve the quality of video.

Some programs only allow you to apply corrections to an entire clip, while others allow you to correct excerpts or to vary the intensity of an effect during a clip.

Using Histograms to Correct Tonal Values

A histogram graphically illustrates the statistical distribution of tonal values within an image or clip. The sliders built into most histogram

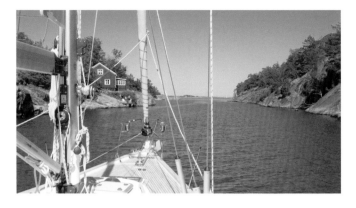

Correcting brightness
Changes in overall
brightness seldom
improve a clip

tools allow you to optimize the white point, the black point, and the gamma value for your image. Histogram tools are generally intuitive to use and quickly produce visible improvements. Unfortunately, not all editing packages include histogram tools, making it necessary to perform this type of correction manually.

Exposure

Exposure correction tools simulate in-camera exposure compensation and make adjustments to exposure that are equivalent to deliberately under- or overexposing during shooting. Here, shadows and highlights are adjusted disproportionately to the midtones, which remain more or less unchanged.

Brightness

Changes in brightness affect all parts of an image equally, and there are only a few situations in which such

global adjustments make sense. It is better to adjust brightness using exposure compensation or using tonal value adjustments in conjunction with a histogram. This way, you can see more clearly whether your adjustments actually improve your picture.

Contrast

Adjusting contrast increases or decreases the relative differences in brightness between various parts of an image. Increasing contrast makes bright parts of an image brighter and darker parts even darker. Reducing contrast has the opposite effect, darkening bright areas and brightening the darker parts. Adjusting contrast changes the relative distribution of tonal values within an image. Increased contrast makes a clip appear more vivid, while decreased contrast makes a clip appear dull.

Contrast
The center image shows the uncorrected clip, while the upper image shows increased contrast and the lower image reduced contrast

Saturation
Adjustments to saturation change the intensity of the colors in an image. Most cameras automatically produce well balanced colors, and changing the overall saturation seldom produces an improvement in overall image quality. However,

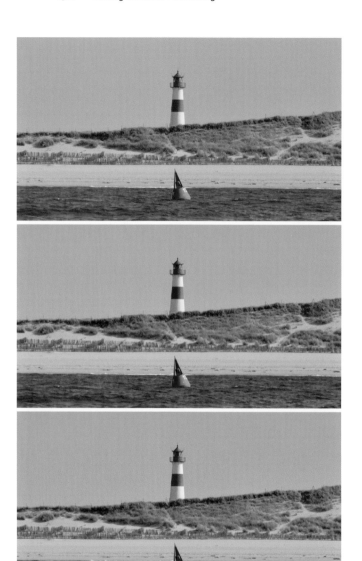

Color saturation

The center image show the uncorrected clip. In the upper image, saturation has been strongly increased to counteract the misty effect present in the original. Reducing saturation as far as possible produces a gray scale image.

selective changes to individual primary color tones can produce improvements if applied sparingly.

Primary Color Correction

Most programs have sliders for adjusting the intensity of the three primary color channels (red, green,

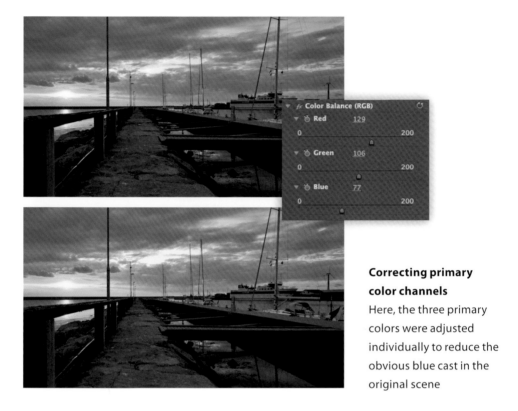

Correcting primary color channels

Here, the three primary colors were adjusted individually to reduce the obvious blue cast in the original scene

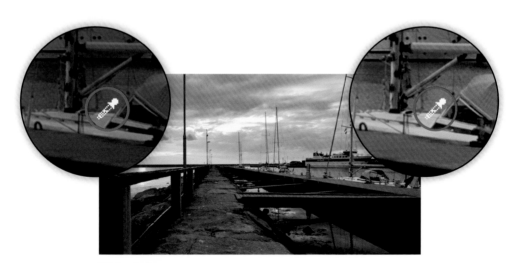

White balance

The same scene before and after white balance correction.
Here, we used the yacht's white deck as a neutral white point.

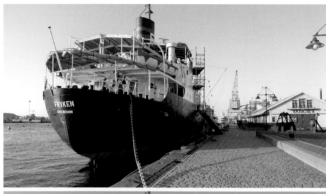

Shadow and highlight correction
Separate, selective correction of shadows and highlights can reveal details in a clip that aren't visible at a first glance

and blue). As an example, you can use primary color sliders to increase the intensity of the color of the sky while leaving the other tones in your image largely unchanged.

White Point

Adjustments to white balance are the most important and effective changes you can make to your raw video material. Most editing programs use a dropper tool to select a neutral point in the image whose white balance values are to be applied to the rest of the frame. White point

corrections are the quickest and most effective way to remove color casts from your footage.

Correcting Shadows and Highlights

Shadow and highlight correction tools are some of the cleverest available to the digital image-maker. Even the most modern digital cameras "see" differently than we do. The human eye can easily compensate for the differences in brightness between objects that are brightly lit and those which are in the shade, and can see fine details in both. Cameras basically

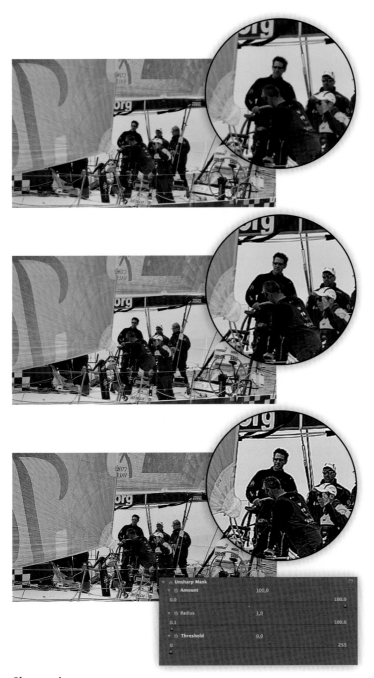

Sharpening

Top: this clip could use some additional sharpening.

Center: perfect. Bottom: too much of a good thing!

Digital Steadycam

This clip—shot on a rocking boat—pushed the image stabilizing
tool to its limits, but it nevertheless produced great results. Note
the artificial reduction in the angle of view caused by applying
the tool.

have to "decide" whether they are going to expose for the bright parts of the frame or the shaded parts. Some of the very latest cameras have built-in firmware algorithms that compensate for extreme variations in brightness and go some way toward producing images similar to those perceived by humans.

Shadow and highlight control tools allow you to make appropriate adjustments to the tonal range of your images at the post-processing stage. This kind of treatment allows you to brighten dark parts of an image without affecting detail in brighter parts of the frame, making it especially appropriate for use with backlit pictures.

Sharpening

If your camera doesn't automatically sharpen your images, check to see if a little extra sharpness improves the overall look of your picture. But take care: too much additional sharpening reduces image quality rather than improving it.

Soft focus effects are less appropriate in a video context than they are in some photographic situations. An individual photo (a portrait, for example) can benefit from a little soft focus, whereas a soft focus scene in the middle of a video sequence is more likely to spoil continuity and could even create the impression that something is wrong with the lens.

Image Noise

Not all editing software includes tools for reducing noise, so it is important to reduce noise as much as possible while shooting. You can always experiment with noise reduction tools if your software has them, but they often produce a visible trade-off of sharpness for noise. Faced with this choice, I prefer to preserve sharpness.

Digital Steadycams

Some editing software (such as Apple's iMovie) include image stabilization tools. In theory you can use any high-end editing program to stabilize shaky footage by shifting each frame individually. The iMovie tool searches a clip for fixed objects and then shifts and rotates each frame separately to automatically remove unintentional camera movements—with surprisingly good results. Remember that applying this type of tool will significantly crop the original frame. You can work around this problem by using a wider lens for scenes in which you think camera shake might occur.

Opening titles

iMovie includes a range of preprogrammed animated title styles—all you have to do is add the appropriate text. Once you have written your titles, you can use the preview button to see how the titles will look once they are superimposed on your clip.

Creating and Editing a Sequence

When a photographer returns from a shoot he has already done about half his work—the other half takes place in the digital darkroom. For a filmmaker, work only really starts once he has finished shooting. Exposure, color and sharpness have to be corrected in video clips just as they do for photos, but the real work lies in the creation and editing of the complete sequence. Post-production

work can take as long, if not longer, than the shoot itself. Experience has shown that amount of time needed to shoot a video compared with the time necessary for processing the raw footage lies in the region of about 1:4.

Editing Basics

Edits are of two basic types. When two chronologically sequential clips are edited together, the process is called an "insert edit". If a scene has been shot using multiple cameras

(for example to capture a shot from various angles), you will often need to replace the footage shot with one camera with that from another in order to preserve the chronology of the sequence. Such a replacement is called an "overwrite edit".

These two basic techniques can be used to combine clips in any number of ways. Once you begin to make your own edits you are sure to find that you can use much more raw material than you probably have. You can never really shoot enough different views of a scene, and having too much raw material to choose from is always better than having too little. A good rule of thumb is to shoot at least twice as much footage as you think you will need for the final edit, although more is always better.

Titles and End Credits

Your choice of typography is the greatest single factor that influences the style of your credits, and good knowledge of typographical basics is a great help when it comes to creating effective titles. The font size and style should fit with the content of the film and must be easily readable. Animated titles and credits should move slowly enough to be read comfortably. Vertically moving type is easier to read than horizontally moving type, and has the added advantage that it can contain several simultaneous lines of text.

Animated titles

Animated titles like these can be created with just a few mouse clicks

Transitions

Editing programs usually include a wide range of easy-to-apply transition effects. Some of these effects are, however, very flashy, and don't improve the film at all.

Better programs provide a preview window to help you judge how a particular effect will look before applying it. The screenshots above show the Sony Vegas Pro and Apple iMovie transition preview windows.

Legibility is the key to good credits and I recommend that you avoid using the complex title effects built into some editing programs.

Transitions

Editing software manufacturers are constantly trying to outdo each other with new, flashy transition effects, many of which unfortunately appear artificial or unnatural. Transitions

Using effects

The range of effects available in modern editing software is almost overwhelming, although you will probably end up using only a very few. The post-modern maxim "less is more" applies to the application of video effects too.

should generally fit with the content of the sequence. For example, two peaceful scenes should always be combined using a calm and unobtrusive transition effect. Many transition effects also move in a particular direction, and these too should fit

in with the action. Never use a vertical transition to combine scenes of horizontal movement. "Less is more" is a good basic approach to the use of transitions, and it is generally better to avoid using overbearing transition effects, except where they are used

The Ken Burns effect
This is an interesting way to integrate photos into video sequences without them appearing static and without interrupting the flow of the action

to deliberately enhance the action. A popular transition effect used in comic book adaptations is to simultaneously show two shots from a sequence side by side before moving on to the next full-frame shot. This technique is impressive and appropriate to the genre, and is absolutely legitimate if used in the right context.

In spite of the huge range of transition effects available at the click of a mouse, traditional transition effects such as a "classic" fade (to black or white) can still be effectively used to convey calm and familiarity in a sequence. An interesting modern variation on the traditional fade theme involves adjusting the end and beginning of two consecutive shots to fade out of and into focus while simultaneously fading to black or white.

Editing Effects
Most editing programs include a range of interesting (and sometimes not so interesting) effects, which can be used to enhance visually dull material. Here too, you need to make sure any effects you apply fit the action, as inappropriate effects often make a film look cheap. Try to use effects that underscore the mood of a sequence the way music does. A romantic scene can, for example, be effectively enhanced by using a soft focus effect.

The Ken Burns effect
Some editing programs have built-in interactive tools for
reproducing the Ken Burns effect (this screenshot is taken from
Apple iMovie). The same effect can also be achieved using
zoom and crop tools.

Using Photos in a Video Sequence

The ability to combine still and moving images at will is possibly the most interesting aspect of working with a modern DSLR. Combining both media in a single sequence utilizes the advantages of both types of image and creates a new and exciting form of multimedia presentation.

The Ken Burns Effect
This effect has been around for many years and owes its name to the documentary filmmaker who popularized it. The technique involves filming still images and photos using pans and zooms, making them appear more dynamic to the viewer. This effect can also be used to effectively integrate still images into sequences of moving pictures and leads the viewer's eye around an image in a way that a photographer cannot. This use of the movie medium to present static images makes it possible for the photographer to influence which parts of

an image the viewer considers to be important.

Three-dimensional (3D) Effects

A digital trick that has become very popular in recent years involves using software to edit two-dimensional images in such a way that they can be viewed in virtual 3D on a computer monitor. This process produces some very unusual effects: zooming into an image, for example, causes objects in the foreground to move toward the background, producing convincing perspective. The overall effect of virtual 3D is fairly artificial, but nevertheless produces a strong feeling of space. There are no fully automatic tools for producing virtual 3D images, and the process relies on the use of manual editing tools. You also need specially shot, separate foreground and background images—or you can extract the various necessary elements from a single image using complex manual retouching tools.

It is also possible to animate individual elements of an image in 3D: for example to make it appear as if smoke is coming out of the smokestack in a photo of a steam train. Such effects are complicated to produce but can give still images a life of their own. Several recent high-end documentary film productions have combined photos from the early 20th century with contemporary film footage. Producing such effects will probably be easier for experienced digital photographers who turn their hand to video than for new DSLR filmmakers with experience in the world of video editing.

10 Rules for Producing Great Edits

Great editing also involves making choices. The following checklist is intended to help you avoid the most common mistakes and to give you a few new ideas to try out.

Stick to Your Original Idea

Stick to your original storyboard. Changing your plan at the editing stage seldom produces good results. It is difficult enough to realize complex film concepts, but hoping that you will come up with good ideas during filming is simply not a reliable way to work. Spontaneous changes always have a knock-on effect in other areas and can even derail a project completely.

Don't Forget the Opening Titles

The opening titles form the introduction to the material that follows and are an essential part of every film. You can either superimpose your opening titles over scenes from your film, or you can run purely typographical titles before the action starts.

In the movie world, opening titles are an art form in their own right, and critics consider some title sequences to be better than the films that follow!

Experiment with Color and Monochrome

Switching between color and monochrome shots can be an effective way to emphasize particular elements of your story; for example, when you change from a subjective to an objective viewpoint. You can also underscore this type of effect by filming objective scenes from a tripod and subjective scenes (i.e., from the protagonist's personal viewpoint) handheld.

Use Contrast Creatively

There is no light without shadow. This maxim is just as true in the movie world as it is in a photographic context. The difference between light and dark can be an effective editing tool in itself, and rhythmic changes of lighting intensity ensure that you will retain the viewer's interest, even over long sequences.

Switch between Movement and Calm

Contrast is an important element of human perception, and changes between fast and slow action or movement and calm are an effec-
tive way to keep a video sequence interesting.

Preserve Continuity

The action in most films is chronological, and breaks in chronology should only be used to indicate flashbacks or other stylistically justified effects. Visual continuity is also very important and exposure, lighting, focus, and grain should all remain plausible and consistent from shot to shot.

Use Transition Effects Carefullly

Transitions should be as inconspicuous as possible. Elaborate transitions should be used sparingly, and only where they serve to underscore the action they cover. Consistent use of a few carefully chosen transition effects can work as a visual signature and contribute positively to the overall quality of a film.

Combine Still and Moving Images

Mixing still and moving pictures is an effective creative tool, and can help to solve previously insoluble visual problems, especially in a documentary context. The Ken Burns effect discussed above is an effective way to blend still images with moving action.

Pay Attention to Sound

Sound contributes much more to the overall quality of a film than most people initially suspect. Bad sound

Export formats

This is an example of a simple export dialog. The user has only a few choices, which means nothing can really go wrong!

can ruin the effect of even the best images, while great sound can help to improve the overall quality of a scene in which the visuals have turned out less than perfect.

It is best to avoid using substandard sound altogether and you can replace an irreparable soundtrack with music if necessary. If you follow the tips in the *Sound* chapter, you should end up with great sound anyway.

Use the End Credits to Give Praise Where it is Due

Everyone involved in a production should be mentioned in the end credits, as should all forms of financial, material, or other support that people or organizations have contributed.

End credits are only usually shown at full length and at the correct speed in movie theaters, and also often constitute an art form of their own. Some famous examples prove that credits don't have to be boring:

Pixar, for example, always enhances its credits with outtakes from the film. Credits don't have to take the form of a seemingly endless piece of vertically moving text, but can also include creative elements that distract the viewer from their otherwise informational nature. Appropriate music can also help make credits more interesting.

Export Formats

The last processing step involves exporting the finished film to a single, viewable master file. This file needs to be stored in a format appropriate to the medium used to present the finished work. Inappropriate formats can make presentation difficult or even impossible.

Not so long ago, you had to know about the codecs, compression algorithms, frame rates, and frame sizes required by your chosen output device. These days, modern editing

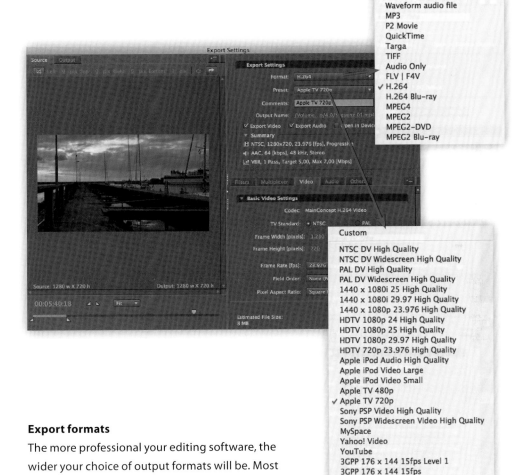

Export formats

The more professional your editing software, the wider your choice of output formats will be. Most programs also offer a wide range of useful presets for use with the most common media types and presentation devices.

software packages have comprehensive export dialogs that include a choice of not only specific formats, but also of specific types of device. The software automatically sets all the necessary parameters for your chosen form of output, making it virtually impossible to make mistakes at the final hurdle.

Presenting Your Work

by Helmut Kraus

At the end of the day, once we have shot, processed, and edited our video, what we all really want is to present our work to the waiting public! And this is where the differences between film and photos really come into focus. A video is a multi-dimensional medium that includes the dimension of time, whereas a photo is always anchored to the present and simply needs to be looked at (whether as a print, a slide, or a page in a book) to be experienced. A film only becomes a film when it is played back, a process that requires a lot more technology than viewing a photo.

Every filmmaker should also be aware that watching a film demands time from the viewer. The viewer of a photo can decide how much time he/she wishes to spend looking at an image, whereas the viewer of a film "surrenders" to the filmmaker for the duration of the video—and it is important that this time is made as interesting and entertaining as possible. The technology used to present moving pictures also plays a significant role in the effect those pictures have, making it important for you to know your way around the available possibilities. The following sections provide an overview of the most popular presentation media.

Online Presentation

YouTube (www.youtube.com) is the largest video sharing website in the world, and its size is also one of its biggest problems. The sheer volume of poor quality films available on YouTube is enough to put many aspiring video artists off right at the start. In fact, most of the clips on YouTube are badly made and make no sense.

There are some pearls to be found, making the Internet a legitimate platform for the presentation of high-quality video, but it is still difficult to distinguish yourself and your work from the huge YouTube crowd.

YouTube's big advantage is the breadth of its viewing public. If you manage to generate interest in your work you are virtually guaranteed a global audience—an advantage that no other platform offers.

YouTube supports just about every current video format, and the following settings will help you to upload and download material quickly and easily:

- Video format: preferably H.264, MPEG-2, or MPEG-4
- Frame format: native (16:9)
- Resolution: 640 x 360 (16:9)
- Audio format: preferably MP3 or AAC
- Framerate: 30
- Maximum clip length: 10 minutes (2 to 3 minutes are recommended)
- Maximum file size: 1 GB

YouTube

YouTube is the largest video sharing site on the Internet. You can give your videos relevant tags while uploading, making them easier to find for people who are looking for specific terms while searching. YouTube videos can be viewed either in a browser frame or in full-screen mode.

Vimeo (www.vimeo.com) is another popular Web-based video platform, with content that is usually of a much higher quality than that offered on YouTube. Vimeo is also a forum used by amateur (and professional) film-makers for exchanging films and ideas. A quick look at some of the comments and discussions running on Vimeo leaves no doubt that its users are a very knowledgeable group of people. You can often find video shot using new camera models on Vimeo, and hands-on experience is

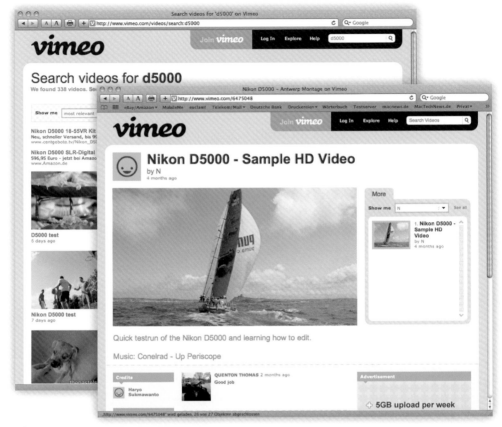

Vimeo

Vimeo is a platform for serious amateur and professional filmmakers. The videos shared on Vimeo are usually of much higher quality than those found on YouTube.

often a better yardstick than manufacturers' brochures when it comes to judging the quality of equipment. You can also use the Vimeo platform to ask filmmakers specific or detailed questions about their work.

Baisc Vimeo membership (with limited webspace) is free, while Vimeo Plus+ membership involves an annual fee (currently $59.95) but gives you unlimited HD upload capacity.

Vimeo recommends the following settings for smooth uploading:
- Video format: H.264
- Frame format: native (16:9)

- Resolution: 1280 × 720 pixels
- Data rate: 3-5 Mbit/sec
- Audio format: 128 kbit/s stereo AAC

Presenting Your Work on Your own Website

An interesting alternative to using established video sharing websites is to use your own website to publish your work. The advantage of this approach is that you can target your material much more precisely and the risk of getting "lost in the masses" is much smaller. You are also not subject to the technical or legal limitations set by the commercial platforms. Remember that it is extremely unlikely that anyone will accidentally discover a private website, however interesting its content may be—although it is still the best way to target friends, acquaintances, or customers.

If you want to use your own website, make sure that your server connection has the necessary download speed and capacity. Many of the free hosting packages on the market don't offer enough of either. Professional hosting involves some costs, although these are usually quite reasonable for a basic HD-capable package.

You should also consider how you embed your video in your website, as a user-side plug-in is always necessary if you want to offer direct playback. The plug-in required depends on the format of your video: Quick-Time (.mov) video is the standard format on Mac computers, but the QuickTime plug-in is not always installed as standard on Windows machines. Most Windows-based computers have AVI-compatible plug-ins installed as standard, while Macs are not usually directly AVI-compatible. Embedded Flash movies are an alternative, although Flash plug-ins can be tricky to configure.

If you are happy to have people save your video files on their own computers, offering your videos for download is a good alternative to embedded video, and allows viewers to choose their own plug-ins.

Vimeo Plus+ accountholders can also use Vimeo's own set of tools for embedding HD video in private websites. The viewer can then view your work just as easily as on Vimeo's own website and avoid the problems caused by missing or faulty plug-ins. Using the Vimeo toolset also streams your video through Vimeo's own servers, guaranteeing that you will not suffer from capacity bottlenecks. You can also hide the Vimeo logo so that your audience can't see that you are using the Vimeo server to host your work.

Hardware

In addition to the hardware necessary for shooting, processing, and editing your videos, you will also need some additional gear to present your work. If you are presenting online, the interface will usually be the computer monitor already owned by your (mostly anonymous) viewers. Monitors are, however, less practical for public viewing purposes, as they are only generally available in diagonal sizes of up to 30 inches. HD TVs are a better solution for larger audiences, as these are already available with 100-inch (and larger) diagonals. You can also use a digital projector to present your video at movie theater screen size.

But you don't necessarily need a a large audience. It can be just as productive to carry your work with you in pocket format (on an iPod, for example) for spontaneous presentation to whoever might be interested. Most portable displays are only suitable for viewing by one or two people, but that is definitely better than noone seeing your work!

The following sections deal with the various types of presentation hardware available and are intended to help you decide which type of device is best suited to your particular needs.

Computer Monitors

Apart from the camera's monitor, your computer monitor is probably the first interface you will use to view your HD videos, as you will most likely be using your notebook or desktop computer to edit your footage.

Sufficient resolution is critical when you are processing HD video and it is a must to be able to see the whole image—i.e., your monitor must have horizontal resolution of at least 1280 pixels for HD footage and 1920 pixels if you want to process Full HD material. An even better alternative is a monitor with 1560 × 1600 resolution, which allows you to view the full HD frame and still leaves space for you to arrange your editing tool palettes on the rest of the desktop.

The "glossy or matte monitor" debate has had a lot of coverage recently. Both types of screen have their own advantages and disadvantages, so it really is a matter of personal taste which type of monitor you choose.

Proponents of matte monitors cannot imagine working with reflections of their surroundings muddying the image or clip they are working on, while the supporters of glossy displays prefer the high-contrast images these screens produce. Colors appear more saturated and blacks blacker on glossy displays.

Processing and presenting your videos
A high-resolution monitor with enough desktop space for your image and your tools is a great help

Both arguments are justified and, if you are still not sure which type of display you should choose, you can simply use your own personal photo print preference as a yardstick. If you prefer to look at glossy prints, you will probably prefer to use a glossy monitor.

Before a fear of reflections causes you to rush out and buy a matte screen, you should first take a look at the lighting in your work environment. A computer-based workspace should be arranged so that no direct light falls on the monitor, and so that neither you nor your monitor is back-lit. Soft, subdued light from a surface source behind and slightly tilted away from your screen is best if you have the choice. The other important factor to remember is that the human eye will instinctively focus on the monitor surface and not the plane containing any reflections, which is further away from the user's eye than the image being manipulated.

If your work environment is suitably set up, you won't have any problems using a glossy screen. If, however, you want to use your notebook to assess and preprocess footage on location, a matte screen is probably the better choice.

HDTV
Apart from computer monitors, HDTVs are probably the second most frequently used HD video presentation device. There are huge numbers of HDTVs on the market,

Glossy or matte?

Whether you choose a gloss or matte monitor is a matter of personal taste. Glossy screens are less suitable for use in bright surroundings, such as outdoors. The upper photo shows a glossy screen in direct sunlight and focused on the reflections in the screen, while the center photo is focused on the LCD panel. The photo at the bottom is of a matte-screened monitor.

Screen diagonal (inches)	Screen diagonal (cm)	Minimum Full HD viewing distance (m)	Minimum HD viewing distance (m)
32	81	1.3	1.8
37	94	1.5	2.1
40	102	1.6	2.2
46	116	1.8	2.6
52	132	2.1	2.9
65	152	2.4	3.4
103	261	4.0	–

Optimum viewing distance

The table lists the viewing distances at which individual pixels are no longer recognizable for the most popular TV screen sizes. Optimum viewing distance depends on resolution, which is why the distance values are different for HD and Full HD devices.

and these are basically split between the LCD and plasma varieties. Even the experts aren't sure which type is better for viewing HD video, so your choice will once again depend on personal taste and, of course, your budget. It wasn't long ago that 40-inch LCD TVs simply weren't available. Things are changing, but the largest TVs are still based on plasma technology.

The sheer number of different labels used by manufacturers to describe the suitability of their products for HD usage can be confusing.

Check what the manufacturer really means by HD Ready, HD-capable, or Full HD before buying. If you want to present Full HD video without loss of image quality, your device's panel must have a resolution of at least 1920 × 1080 pixels. Many "HD" TVs are built using panels with resolution as low as 1280 × 720 pixels.

Remember, HD resolution is limited, however tempting an enormous screen might seem. If a screen is too large for the viewing distance at hand, image quality will suffer. The viewing distance should be neither too great

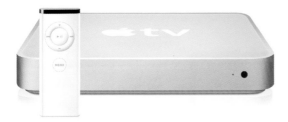

AppleTV

An AppleTV box can be used to view photos and videos on a TV screen, and to listen to music stored elsewhere on the network

nor too short if you want to be sure of producing a great visual experience.

If the viewer is located too near the screen, the texture of the individual pixels built into the screen can spoil the detail in your images. If the viewer is too far from the screen, the high HD resolution will no longer be visible.

In order to get your video from your computer's hard disk onto the TV screen you need a cable to connect your graphics card with the TV's HDMI or DVI input socket. This will present no problems if your TV has the same interface as your graphics card, but you will need an adapter cable if they are different. HDMI has the advantage that it can simultaneously transfer sound and visuals while DVI is a pure video standard.

Instead of connecting your computer directly to your TV, you can also use a Blu-ray recorder or the handy AppleTV box to show your videos. Blu-ray burners are, however, still fairly rare.

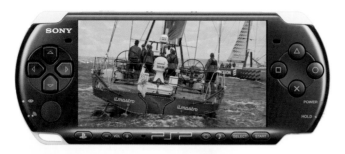

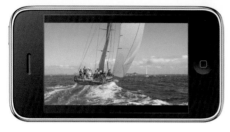

PSP and iPhone

In spite of their small screen sizes, both these devices (shown here at half life-size) are very popular for viewing video on the move

Photo: Apple Inc.

Full HD Notebook

Notebooks with large monitors are great for viewing HD video at full resolution

Mobile Devices (iPhones, iPods, notebooks and smartphones)

Video can be played on a large number of mobile devices, including iPhones, some iPods, a whole range of mobile phones, and Sony's portable PSP and PSPgo consoles. All of these devices do, however, have screens with resolution below that of HD video.

Portable devices have the advantage of being able to play video

anywhere and at any time without the need of a power outlet.

When it comes to viewing video on the road, large-screen notebooks are even better than the pocket-sized devices mentioned above. Some 17-inch notebooks can even display Full HD video at full resolution.

Multimedia Projectors

If you want to show your HD videos to a larger audience, a multimedia projector is probably the best way to go. Like the camera used to shoot the original material, this modern equivalent of a film or slide projector can handle still or moving images equally well.

There are three major types of multimedia projector currently available. **LCD** (Liquid Crystal Display) projectors use the same basic technology as their namesake monitors, and utilize a transparent LCD panel backlit by a strong light source. The resulting image is then projected onto a wall or a free-standing screen using a lens. **LCOS** (Liquid Crystal on Silicon) projectors use similar technology to projection TVs, but use liquid crystals in place of mirrors. The (technically) most interesting projectors are based on DLP (Digital Light Processing) technology. A **DLP projector** uses movable micro-mirrors to reflect a strong light source. These mirrors can be repositioned rapidly to reflect light either through a lens or onto a

Device	Display resolution (pixels)	Display size
PSP	480 x 272	4.3"
PSP go	480 x 272	3.8"
iPhone iPod Touch	480 x 320	3.5"
iPod nano	376 x 240	2,2"

Screen size and resolution
for video-capable mobile devices

heat sink (also called a "light dump"). Rapidly toggling the mirror between these two orientations (essentially on and off) produces gray scales controlled by the ratio of on time to off time. Color images can also be produced by placing colored filters in the light path. DLP devices have a greater range of color and contrast than other types of projector. DLP projectors produce extremely homogenous, almost analog-looking images due to the fact that they only project light for each pixel that actually exists in the image, and do not project the structure of the entire panel the way other projectors do.

Just like with an HDTV, you need to make sure that your projector's resolution is at least equal to that of the material you want to project (i.e.,

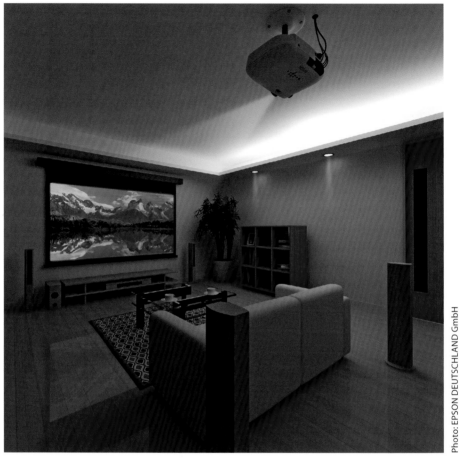

Photo: EPSON DEUTSCHLAND GmbH

Multimedia Projector
This illustration shows a high-end home projector setup

at least 1920 × 1080 pixels for Full HD).

A projector's lens should be powerful enough to allow you to position your entire audience between the projector and the screen, and high-quality models have either interchangeable or zoom lenses. A built-in lens shift capability is also important in order to prevent the image being projected as a parallelogram when the projector cannot be positioned exactly parallel to the projection surface.

Like HDTVs, most projectors can be connected directly to your computer's graphics card using HDMI or DVI cables.

Photo: Philips

Presentation sound
A notebook with external
accessory speakers

Photo: Pioneer

Presentation sound
A home theater system
with 5.1 speakers

Sound

Presentation sound should always be as good as the circumstances allow. Even if you are "only" presenting to two or three people using a notebook, you should still use accessory speakers to emphasize your sound. A little extra sound always helps to make your images appear "bigger". If you are presenting using a projector or an HDTV you should use a 5.1 (or better) speaker system, even if your soundtrack is technically not capable of reproducing anything more complex than stereo sound.

Moving from Still Photography to Video

by Uwe Steinmueller

In this chapter my wife Bettina and I share our personal journey as we moved from still photography to video. While we mainly practice still photography, we now also embrace video, and it all started with the new Video DSLRs. You might ask why we did not just buy a video camera to start with. Well, we did, but it never took off for us. Video DSLRs, with dual still and video capabilities, offer the great advantage of requiring only one bag with one camera and one set of lenses—it's more convenient than two cameras, less bulky, and weighs less when traveling. Also, the new Video DSLRs, with their lower depth of field (DOF), have a more filmlike look than the common video camera, and we wanted to explore this intriguing new capability.

There were other reasons why we wanted to learn to make movies; maybe some of these are your reasons, too. For instance, we believe that learning to tell a story through creating a video will help to improve our still photography; we'll be able to document the locations where we take still photos; and we want to make short movies, since even they can be compelling and revealing.

In the pro world, making movies is a team effort with many people involved. In still photography, photographers often work alone, and we are keeping that soloist mentality as we move to video. At this point we are only interested in short movies that Bettina and I can make ourselves.

Note that we may repeat some topics already covered in this book, but this time they are coming from our own perspective.

Entering the New World of Video

Still and Video: A few similarities, many differences

Both still photography and video embrace light and require good framing and composition. Now, both can be captured with the same camera. There are other similarities, but there are many more differences than might be apparent at first.

The first (and most obvious) difference is that video records movement as it happens, while still photography freezes only a short moment—each shot distinct from every other. In video, movement in the scene, or motion created by manipulating the camera, tells the story and contributes to the final product: a film.

Movement captured by filmmaking happens in the scene itself (the action of the subjects we are filming) or is generated by the moving camera. We may have little control over what the subjects are doing, but with some forethought and skill we can at least control our camera's movement. Camera movement allows us

to see the same scene from various angles as we move the camera while focusing on the subject (the subject may stay still, but the camera moves around it). This again is a major difference between video and still photography, since the still photographer has to freeze the motion even when creating a motion blur.

Camera motion should be as smooth as possible; this is an art in and of itself. Some high-speed action films deliberately use jerky, rough camera movements. You may want to jiggle the camera around slightly in order to simulate shaky home movies, but generally, smooth is the rule. One of our major challenges when learning to shoot video is mastering smooth camera movements, and figuring out when to use them and when not.

Another major difference between still and video photography is the ability to incorporate sound into your filming process. As you know from watching any movie or TV show, sound adds dimensions to video and creates a much richer experience for the viewer, effectively making the movie complete. Sounds include music, speech (dialog), and noise present in the scene we are shooting.

Mastering camera motion while learning videography is challenging enough without worrying about the sound portion of the equation. For now, we just add simple music

soundtracks to our movies so we can avoid this particular can of worms. We find it easier and more rewarding to learn this process step by step, focusing on the video components first, and recommend that you do the same. We discuss adding sound later in this chapter.

Telling Your Stories

It has been said that a picture tells a story, but in reality, still photographs help create a story in the viewer's mind. Here is another area where video differs from still photography, for filming allows the photographer to become a real storyteller. A movie—unless it is completely spontaneous in nature—has a beginning, a middle, and an end, and follows some sort of storyline; this is why most professional videos start with a script. Scripts are sometimes based on works of fiction, although the script often differs significantly from the original work. Reading a story creates a mental picture, while movies present stories directly to us. Movies tend to leave less room for viewers' imaginations to add to or supply information in the stories, although the best movies manage to both tell the story and inspire the imagination. We are not yet into creating fictional movies—we are interested in making short documentaries, learning as we go.

Working without a Script

When we go filming, it's very similar to our photography trips: we visit locations we're interested in and capture images and video clips in transit, rarely going back to revisit places we've already filmed. There is usually no way to go back and capture missing footage, which means we have to create our short documentary using video we obtained on that initial visit.

During your filmmaking forays, remember to be on the lookout for clips that would make an entry or end clip for your movie. Be cautious about deleting scenes on the go, before you get a chance to edit, because you never know what you might want to use. The nice thing about movies (compared to stills) is that minor clips or scenes can contribute to an interesting mood or help flesh out the final cut of your movie.

Editing

Once you have all your footage, the editing process creates the real movie. Editing cannot take the place of good footage, but editing helps to get the best out of the raw film you have. Different editors can tell very different stories using the exact same footage. You'll need to be comfortable using video editing software and procedures (or you can hire a good film editor). Like we said, the movie is really made during editing.

Later in this chapter we will talk about basic editing steps.

Important Technical Issue to Consider

Compression: your friend and enemy

It helps to understand the types of video compression performed by today's Video DSLRs. Without compression, the camera memory card would be full in no time. Uncompressed video would also quickly exceed the maximum sustained write speed, meaning that it would be attempting to write to the memory card faster than the memory card could save ("write") the images. Compression, therefore, is essential to a Video DSLR working properly for any length of time.

All cameras need to limit the bit rate (maximum data per second created for the video stream) to ensure that the recording does not exceed the memory card's maximum sustained write speed. This is done through the compression process. Three main compression schemes are currently used in DSLRs:

- **MJPEG** (Motion JPEG) codec, used by Nikon and Olympus
- **MPEG-4 GOP** (Group of Pictures) codec, used by Canon
- **AVCHD GOP** codec, used by Panasonic

The GOP cedecs compress a group of images as a whole. The first frame in the group, although still compressed, is stored in full. The subsequent frames of the group store only delta information to the first one. This means that the compression scheme is very efficient if nothing moves in the video, but it's more challenging if things move fast. DSLR cameras often have fast processors for performing this complex compression task. There is a downside to GOP compression codecs: they do not perform well during video editing. That is why we transcode (convert from one codec to a different one) all our footage to a higher quality non-GOP codec (e.g., Apple ProRes LT) for further editing. Examples of when we use transcoding is covered later in this chapter.

MJPEG, unlike the GOP codecs, compresses each image independently. Although this is a plus, it also means that at a given bit rate the JPEG compression is more lossy (resulting in a lower quality image).

All these camera codecs use something called chroma subsampling, whereby the compression process discards some of the color information. This is mainly an issue if you later want to perform major color editing (e.g., significantly change the white balance).

Compression dramatically changes the video you are saving, and reduces the options for major editing at a later time using video editing software. For comparison, still photos comprise only RAW (uncompressed) images, which have 12–14 bit image data, and are often lossless compressed (highest quality). But the data from video DSLRs is just 8 bit, and is quite lossy compressed (lower quality). Note that a single 1080p HD video frame comprises just 2 megapixels of data (very low resolution compared to today's still cameras).

Why should you pay attention to these matters? Because you need to shoot in such a way that your film doesn't require major corrections during editing. Good exposure is even more important than with RAW still images.

Picture Style Matters

If you, like us, usually shoot RAW for stills, you've never paid much attention to the DSLR picture styles available for stills. The picture styles feature is mainly used for defining the style of JPEG images—not applicable to RAW. With video, though, we need to pay attention, because now we're dealing with JPEG images. This

Picture Style
Our settings for Canon 5D Mark II and 7D cameras

means the picture style function on your camera is important for shooting videos.

There is a universal rule in picture editing stating that each operation degrades image quality to some degree. A related tenet is that while it is easy to add contrast to soft images, it is difficult or even impossible to reverse the process. Because of these issues, it's better not to over-process images while they are still in the camera—it limits your options during post-processing. This is even more important if we're dealing with a high level of compression, as we are with video.

We keep in mind the idea that "less is more" when dealing with picture styles. A general guideline is that upping the level of a function does the following: the sharpness function creates crisp edges, contrast

makes images pop more, and saturation intensifies colors. Color tone, a fourth option, is a setting we don't usually alter. We generally try to find a balance so that the images are soft and yet not too lifeless right out of the camera.

We use the settings shown in the illustration for our Canon 5D Mark II and 7D cameras. Note the following:

- For maximum flexibility in post-processing, set sharpness and contrast to the minimum
- A compromise with slightly lower-than-middle settings on sharpness, contrast, and saturation (as shown in the illustration) will still allow some latitude during editing
- We don't recommend setting higher values on any of the functions
- Color tone is based on your taste (we leave it as it's set by default)

White Balance (WB)

Finding the right white balance for your shots is crucial. As you know, white balance in RAW still photos can be adjusted during your shoot without affecting RAW processing. Unfortunately, this is not so with shooting videos and processing the resultant JPEGs. It's essential to get the white balance at least into the right ballpark during video shooting. You'll find that sometimes the Auto WB is not good enough, for instance, when filming in the shade. In that case, we can use the camera's WB presets (e.g., shade) to get close. This way we only have to perform minor WB corrections later.

Here are some suggestions for dealing with white balance:

- **Sunlight:** use the Auto WB setting
- **Shade:** use the camera's shade setting
- **Indoor shots:** experiment with other settings
- **New light situations:** Be sure to change the WB whenever you move to a new lighting situation. It's best to set it back to Auto WB (AWB) after every shoot.

Resolution and Frame Rate

We always like to use the maximum resolution possible with our main DSLRs, which have 1080p (also called full HD). A 720p camera can also deliver very good results, but you may run into issues like moiré because of the lower resolution.

In theory, the higher the frame rate the smoother any movement will appear. Then there is the wonderful look of classic films, which are shot at 24 fps. Many filmmakers prefer 24p over 30p. We are not yet sophisticated enough in our video-making knowledge to appreciate the difference. The newest Canon cameras, as of January, 2010 (EOS 7D and 1D Mark IV), offer both 30p and 24p.

There are even faster options, which is good if you plan on shooting in slow motion. Some of the newest cameras allow filming in 60p, but mainly at the lower 720p resolution. You have to pick your poison.

Aperture and Shutter Speed

Exposure is different in video versus still photography. The normal shutter speed for video should be 1/(fps * 2). This means:

- 1/48 (only 1/50 available) for 24p
- 1/60 for 30p
- 1/120 (only 1/125 available) for 60p

These shutter speeds, when used for still photos, would often create images with motion blur. But that is exactly what you need for video, since the motion blur keeps the motion in the movie smooth.

A too-high shutter speed will create some sort of flicker in your video.

Conversely, if you set the shutter speed too low, the camera won't be able to keep up with the frame rate. A balance is what you're looking for.

What to do if the light is very bright

Because the shutter speed for video is fixed and your aperture depends on the DOF, you need to use neutral density (ND) filters to adjust the exposure. Fortunately, since changing ND filters is a major hassle, there are variable ND filters made by Singh-Ray and Fader. We often control the exposure just by adjusting our Vari-ND filter (Singh-Ray).

What to do if the light is low

Since the shutter speed is essentially fixed, you have two options: use a higher ISO, or use a wide-open, faster lens. Higher ISO introduces more noise. In this area, some DSLRs clearly outperform video cameras with smaller sensors. A Canon 5D Mark II still performs very well at ISO 1600. It's best to use faster lenses wide open to keep ISO in a range that ensures that the noise does not overly impair the video quality. Fast, wide open lenses produce lower DOF, which often contributes to a more filmic look. Note that working with a shallow DOF requires precise focusing.

Shooting Clips

Lenses

In normal daylight we mainly use our more flexible zoom lenses on a Canon 5D Mark II or with our Panasonic GH1. The lenses we mention below are mainly useful for full frame DSLRs. If you use a camera like the Canon 7D (which features a 1.6x multiplier APS-C sensor), you have to get lenses that match the effective focal length of these lenses.

- Canon 17–40 mm f/4
- Canon 24–105 mm f/4 IS (our most universal zoom for video)
- Canon 70–200 mm f/4 IS
- Panasonic 14–140 mm f/4–5.8 OIS (equivalent to 28–280 mm on full frame DSLR)

For low light we use fast prime lenses like:

- Canon 35 mm f/2
- Canon 50 mm f/1.2
- Zeiss 21 mm f/2.8

You can also use manual focus (MF) lenses from Nikon, which require an adapter. The manual focus lenses work with both the 5D Mark II and the GH1.

Zoom Effect

Zooming in or out of a scene should be done very sparingly. Also, make sure that your zoom stays in focus while zooming. Bear in mind that

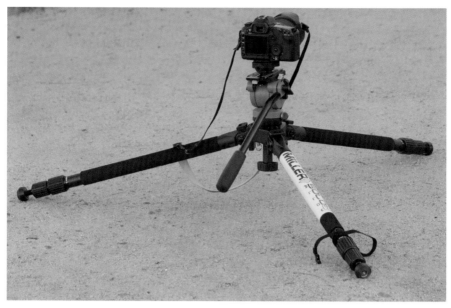

Miller DS-10
A reasonably light tripod featuring a good fluid head

most DSLR zooms are not very smooth during zoom.

Stabilization and Camera Movement

We quite often photograph without using a tripod, but almost always use one when shooting video. This means that a good video tripod/head combination is crucial to successful filming. Don't rely on the image stabilization in your lens, either, because while it helps with single shots, it can't do much for video.

Finding a good tripod for still photography is complicated. You need to consider many factors, including:

- Weight
- Size
- Solid, sturdy (to stand up to twisting, the wind, vibrations)
- Solid ball head
- Can be used outdoors / weather resistant
- Price

These considerations become more complex if you plan to use one tripod for both video and still photography. We usually use our tripod when shooting outdoors.

The specifications for video tripod legs are similar to those for a good photo tripod. Unfortunately, your

Camera

Arca-Swiss style plate
attached to the camera

Arca-Swiss style clamp
with socket, which allows the
clamp screw to work properly

Video quick release plate
(different for all manufacturers)

Fluid head

Leveling base
(here part of the DS-10 head)

Tripod

Our tripod head setup

beloved ball heads don't work for video, because although the tripod/head needs to be rock solid (the same as for still photography), for video you also want to be able to move the head around (pan and tilt). And the head needs to move smoothly. When shooting video, the phrase to learn and live is "smooth movement". All camera movement should look like a smooth glide, but all ball heads fail miserably at this. Like it or not, you

need a good fluid head for shooting your videos. You'll find that using a small DSLR is even more challenging because the low mass of the camera provides very little resistance to the movement of the head.

Let's look at the criteria list for a DSLR tripod and head, for use only with a video camera. Differences from the previous list are in italics:

• Weight
• Size

Arca-Swiss style clamp
Attached to the video quick release plate (a special one for video made by Acratech is shown)

- Solid, sturdy (to stand up to twisting, the wind, vibrations)
- *Smooth fluid head*
- Can be used outdoors / weather resistant
- *Able to use the same tripod and head for tripod-based still photography*
- *Able to switch quickly between video and freehand still camera use* (this is quite tricky; see below)
- Price

If you plan on using pan and tilt during filming, which is not necessarily a requirement since not everyone uses pan or tilt, you can't use a lightweight tripod as they tend to twist during pans.

We finally settled on a Miller DS-10 tripod and head, which is not a cheap solution—but the head moves smoothly. When purchasing a tripod, also check for the following:

- Make sure you can get down low to the ground. An external monitor or a swivel LCD (like the one featured on the Panasonic GH1) works very well for this.
- The tripod should include a leveling base (which is part of most professional video heads).

Attach an Arca-Swiss style clamp to the video quick release plate, so that you can use the camera as a normal still camera, on ball heads, as well as a video camera.

We cannot overemphasize how important a tripod is when shooting video. The most important camera movements to practice are:

- **Pan** (move horizontally). This is used often.
- **Tilt** (move vertically). Quite rare.
- **Pan and tilt simultaneously**. Not that common.

There are many other tools available to move and stabilize cameras:

- Steadycams (need a lot of experience)
- Dollies (pretty soon you'll need a crew)
- Gliders
 We use a Glidetrack Shooter glider that can also be used as a shoulder

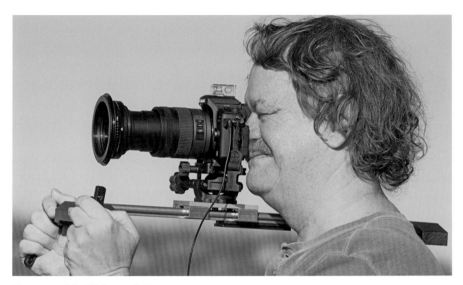

Camera with Glidetrack Shooter
Can be used as a glider or a shoulder mount

mount for small cameras, as shown in the illustration. It works reasonably well if you utilize anti-shake software during the editing process (discussed later in this chapter).

- Cranes (even small ones can get big)
- Other rigs for handheld shooting

Filters

Some filters are essential for video:

- **ND and Vari ND Filters:** These help to keep the shutter speed low in bright light. We use Singh-Ray and Fader.
- **Graduated ND:** When we photograph stills, we often handle higher dynamic range by shooting for HDR. This is not yet an option

in video and is why the old classic graduated ND filters are often needed.

- **Soft filters:** To prevent overly sharp images of faces.

Focusing

With most DSLRs, auto focus does not work during video shooting. Manual focus requires both a good viewfinder and experience.

Keeping scene elements (particularly moving people) in focus is challenging. This process is called pulling focus. There is normally a dedicated focus-puller on movie sets; to pull focus you need special rigs and gear as well as relevant skills and experience.

Zacuto Z-Finder

3x optical magnification

Focusing using the LCD is nearly impossible. Instead, we use a Z-Finder 3x magnifying viewfinder for our 5D Mark II when we want to shoot handheld.

Shooting Footage

Here are some tips for shooting your videos:

- Always try to start shooting early before the real action begins, even though this can be difficult when shooting ad hoc footage. The first few seconds of a clip are frequently unusable, since it's easy to shake the camera when hitting the record button. Using a remote release can prevent camera shake.
- Make clips longer than you think you will need.
- Be aware of disturbing elements in the scene (such as action in the background, people or animals entering the scene, and more).

- Always record sound. Most of the time we discard the sound, but at least we have it if needed. We can also use the sound recordings taken during shooting for synchronization with external sound recordings.
- Be aware of any bad ambient noise if you plan to use the sound recorded by the camera.

Shooting for Common Special Effects

Both slow motion and time lapse are very popular effects.

Slow Motion

The principle of slow motion is easy: record at a higher frame rate and replay at a lower frame rate. Unfortunately, your camera has to support higher frame rates to make this work. As of this writing (January, 2010), the new DSLRs only support up to 60 fps, and then only at the lower 720p resolution. You may be able to capture 30 fps and then slow it down in the editing process, but it certainly won't look as good as if you had 60 fps in the first place.

Time Lapse

Time lapse is the opposite of slow motion: record at a lower frame rate and then play back at a faster speed. There is no way to slow down the speed in-camera with today's breed of DSLRs. If you want to speed up

the replay just a bit, though, you can record at 30 fps and change the speed in the editing process. Shoot stills at certain intervals to condense longer processes into a short sequence.

Fortunately, there is a very easy way to create time lapse sequences with your DSLR because it is a still camera in the first place. We use an intervalometer like the Canon TC-80N3; some Nikon SLRs have it built in.

Following are easy steps to shoot and create a time lapse clip.

Canon TC-80N3 remote control

Shooting Time Lapse

1. Be sure the battery is fully charged.
2. Disable LCD preview to prolong battery life (or use an external power supply).
3. Mount the camera on a sturdy tripod.
4. Capture at medium or full-sized JPEG. JPEG quality is still beyond the normal video quality, and the size is even bigger than 1080p.
5. Try to stay at about the standard video shutter speed, although it is not as important here because time lapse sequences don't look smooth anyway.
6. Check for the proper white balance.
7. Frame the scene.
8. Focus manually, and keep the focus constant.

9. Make a test shot to determine the best exposure (if the light changes in the scene, you might also consider auto exposure).
10. Hold your hand or fingers in front of the lens to mark the sequence start.
11. Set the intervalometer to your selected image frequency. Note that too many images (higher frequency) is better than too few (lower frequency).
12. Most of the time, you don't want to limit the maximum number of shots. Shoot until you manually stop the process.
13. Start the process.
14. Check that the camera is doing its job.
15. Stop the process when you deem it finished. Remember, shooting longer videos is better than making videos that are too short.
16. Once again hold your hand or fingers in front of the lens to mark the sequence end.

Editing Time Lapse

1. Perform minor WB corrections on all sequence images in the batch (e.g., in Adobe Lightroom).
2. Do the same with sharpening, contrast, and minor color corrections.
3. Assemble the images into a movie sequence (we use Quicktime 7 Pro).
4. Insert the time lapse clip into your normal editing timeline.
5. Crop and resize (the image is bigger than 1080p).
6. Consider combining with zoom effects performed on the sequence.

HDR Time Lapse

Time lapse can even be done in HDRI (High Dynamic Range Imaging) by capturing three to five exposures instead of one. Then use Photomatix batch processing to create tone-mapped results.

Overall Workflow

Script or equivalent

Start with a script or some sort of storyboard. As we've talked about before, the film is really made during editing, but you need to have a good selection of video clips from which to assemble your story. Think of it like solving a puzzle as you put the (trimmed) clips together into a storyline. Remember, if puzzle pieces (clips) are missing, your story will have holes. This wouldn't be much of a problem if you could re-shoot, but much of the time that's not an option. Unless you have a really well thought out plan for your editing, be sure to capture enough clips so you can experiment during editing and avoid holes in the story. It is also important to think about clips that might be good for your movie's start and finish. Beginning and ending scenes should frame the story.

Shooting Clips

- The new DSLRs are not very good at helping with auto-focus when shooting a clip; even the Panasonic GH1 has quirks, and it is still in many respects the most advanced of the new DSLRs. If you don't want to use follow-focus (which is an all-new challenge by itself), then it's best to focus before you start recording and keep enough DOF reserve for everything that may move during your shoot. Narrow DOF looks nice but may result in undesirable out-of-focus people or objects.
- Shoot longer clips than you think you may need.
- Slightly underexpose rather than clip your highlights. Most DSLRs do not supply proper exposure histograms during video recording. If in doubt, shoot a very short test

Sample file hierarchy for video files from cameras with continuous file numbering

clip and check the histogram during replay.

- Use a sturdy tripod whenever possible.
- Check to make sure you have set the proper picture style.
- We nearly always shoot at 1080p, except if we plan to create slow motion, in which case we use 720p at 60 fps. Some argue that 720p is not much worse than 1080p, but we have seen many cases where 720p creates an unattractive moiré, so we shoot at the highest quality that our camera can deliver.

Copy your Clips to Your Computer

- Make it a habit to leave your original clips untouched when you save them to your computer; don't forget to back up your valuable footage. It's tempting to work on our clips right away—we're always in a hurry to see what we've got. That is why a systematic workflow that includes backup is so important.
- Next, rename your files (clips). A good file/folder structure is essential. You want to be able to find the original (untouched) clips that match the clips you use during editing. Most clips will never even enter the real editing process, which we'll explain in the sections about Preview and Pre-Trimming.

The goal is to have a unique name for every clip you may ever shoot, like this example adapted from our still photography (the suffix may also be .AVI): video_09125D2_2402.MOV

A breakdown of the name follows:

Sample file hierarchy for video files from cameras using the AVCHD structure (e.g., GH1)

Folder	Content
digi_inbox 2009	stills and video
inbox_2009_12dec	month, stills only
20091215_5D2_PointLobos	session, stills only
video_inbox_2009_12dec	month, video only
video_20091215_5D2_PointLobos	session, video only
TimeLapse	for time lapse stills

This is our complete folder hierarchy template

- **video_:** Identifies the file as a video clip and not a still photo.
- **0912:** 2009 December (12). Except for the AVCHD cameras (like GH1), we don't include the day because the same image/video number won't show up in the same month unless you shoot more than 9999 per month.
 AVCHD cameras reset at each formatting to 0. That is why, for these cameras only, we also include the day in the file name. If you use more than one card per day, you'll need to find an additional way to make each shot identifier unique.
- **5D2:** Short sequence identifying the camera used. If you have more than one Canon 5D Mark II you would use 5D2a, 5D2b, etc.
- **2402:** The original sequence number from the camera.

We use a simple, free Mac routing called "Renamer4Mac" to rename our clips.

Each card or shoot gets filed into its own folder: "video_20091215_5D2_PointLobos". We add a short name for the shoot, for example, "PointLobos". The other parts of the folder name are the camera and the date. We have one common root folder per month for all videos, and a separate monthly folder for stills. The yearly inbox folder is at the top of the hierarchy.

As shown, we actually have a third category of files that is neither still photographs nor videos: TimeLapse. Technically speaking, these are still photos, but Time Lapse still photos only make sense for us in the context of the full sequence.

Transcoding

Transcoding is essentially converting from one codec (the original that came with your camera) to another one that works better for editing. It is the process of transferring your video clips from a higher compressing codec to a lower compressing one. As explained earlier, the codecs used by our DSLRs are not well suited for direct use during editing (although some of the codecs that are supplied with the camera may perform decent editing). We use Apple's Final Cut Pro 7; a codec like ProRes is also a good choice for editing our movies. We like the ProRes LT version, which

> **Note**
>
> We should be careful what we wish for. Lower compression means much larger clips and more processing power needed for our computers.

allows us to transcode all our material without major loss of quality. The footage from our Panasonic GH1 is recorded in AVCHD and requires some care to convert (the conversion needs to convert a 24p clip encoded at 60i in camera back to the real 24p footage).

Transcoding from a higher to lower compression rate prior to editing ensures that we preserve all of the quality we captured during filming. Keep in mind that your camera already throws away some information while recording to the camera's codec, due to compression (as discussed earlier). The image quality that can survive this process is actually quite amazing. Regardless, right now there is nothing we can do about the technical issue of information being tossed during initial compression. We hope and believe that future cameras will offer a lower compression option with the camera's own codec, and much more information will be saved during the process.

For transcoding clips we use a program called NeoScene. NeoScene

NeoScene

Allows proper 24p transcoding for GH1 clips

does a good job for transcoding the GH1 AVCHD .MTS files, and performing a pulldown from 60i to 24p. It also works fine for the Canon 5D Mark II and 7D.

During transcoding, files easily become four to seven times larger than the original file. That is why we transcode to a temporary folder—we also do this because a lot of our footage will be rejected or trimmed during the next step (see below). Still, it's a good idea to have all the transcoded clips available while we work on a project, and the temporary folder serves the purpose of corralling all such clips. Some projects may span several

months' worth of shooting, while others use clips from just one shoot.

Viewing and Clip Rating

Our main video browser is Adobe Bridge CS4, which comes with Photoshop CS4.

Next, we get ready to view all our clips in QuickTime 7 Pro (launched from Bridge). Each clip gets an initial rating:

- Useless clips (e.g., camera running while we walk) get deleted right away. This is not a critical operation because we can delete these unwanted clips at any time. But remember, we never delete original clips. Video thumbnails in

Adobe Bridge

You can watch clips inside Bridge, but we prefer to watch them full size in QuickTime 7 Pro (an inexpensive upgrade from basic QT 7).

Bridge only show one frame. This means a seemingly useless clip might have useful material hidden inside. Therefore, it's best to carefully review every clip. Also keep in mind that even a short three-to-five-second sequence could be useful later during editing.

• Clips that may make it into a movie get rated with three to five stars.

Note

Mac OS 10.6 (Snow Leopard) comes with QuickTime 10. You would think this is an advanced version of QuickTime, but unfortunately it is not as powerful as QT 7 Pro. On the plus side, Snow Leopard does allow us to install QT 7 Pro in addition to its pre-installed QT 10. We have set up Bridge so that it always opens .MOV videos in QT 7 Pro.

- Clips that most likely will not be used, but may be needed as a backup, get one to two stars.

One of the challenges with video is the amount of data that can quickly pile up. This is especially true after we transcode our clips to Apple ProRes LT, and explains why we pre-trim our clips before we add them to a new project folder (we discuss pre-trimming below).

Project Structure

Before we even open our video editor, we create the following project folder structure for each movie:

- **Clips:** contains all pre-trimmed video clips (see below).
- **Images:** contains still images, if the project has them.
- **Music:** contains music clips.
- **Notes:** contains project notes or other written material (e.g., text for Vimeo).
- **Projects:** contains project files. We use abbreviated versions of our project files (small files that contain links to clips and music, not full the files).
- **Rendered:** Contains the various exported movies, sorted by export format. Again, we may have different versions. Note that we include the output format as part of the name.

Pre-trimming of Clips

Now it's time to revisit our three-to-five-star clips and look for sequences that we may want to use during editing. With QuickTime Pro 7 you can select In/Out points, where In is the start of the sequence and Out is the end.

We have a hard time remembering keyboard shortcuts, but some are just too important to neglect to mention here:
- In point: "I" (the letter I)
- Out point: "O" (the letter O)

Don't shorten the sequence too much, because you want to have some latitude for trimming during the final editing process. We trim the sequence in QT 7 and save the trimmed clip to the project's "Clips" folder. We often add more text to the video file name, but keep the base name as part of the final name. This way we can easily find original clips if necessary (e.g., we trimmed too short or even deleted the temporary transcoded clips).

20091110_Zion_VariousCameras

A new folder for each project. The project folder should be a self-contained unit, so that even if you move the folder to a different disk, all important relations remain intact.

Project folder structure

The folder "projects" contains project files

Project folder structure

The folder "rendered" contains the various exported movies

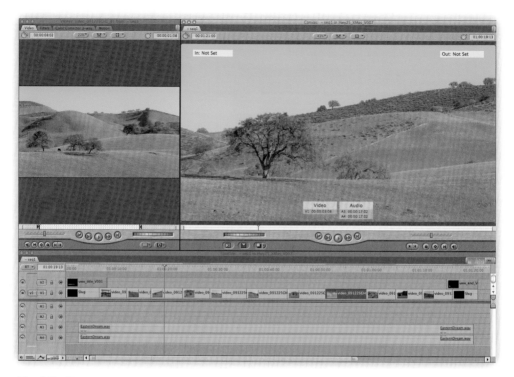

Final Cut Pro
Our standard NLE video editor

Editing Basics

This is by no means a full tutorial on editing; we just want to show you some basic elements of editing, those that we use all the time, to get you started. We expect that you'll want to refer to other sections of this book or look up more information about it on the Web.

HD NLE Editor (we use Final Cut Pro 7)
NLE stands for Non-Linear Editing. This means you don't need to edit in a strict linear fashion—you can always add new clips, change clips around, and do much more. There are quite a few good NLE programs on the market, including the following (listed from least to most expensive):

- **Windows:** Sony Vegas, Adobe Premiere Elements, Adobe Premiere Pro
- **Mac:** iMovie, Adobe Premiere Elements, Adobe Premiere Pro, Apple Final Cut Pro

Sample cache setup for Final Cut Pro

In this case we use one drive for all cache files. This drive is not used for the OS caching.

We settled on Apple Final Cut Pro Studio 3 (which includes many more features than just Final Cut 7) because we're going to be making movies for a long time, and learning an NLE editor is a big investment of time and energy. Final Cut Pro (FCP) is the dominant tool for many independent filmmakers—you might say it's the Photoshop for videos. There are also more plug-ins available for FCP than for any other editor.

After spending some time using FCP we were very pleased with our decision. FCP is not too hard to learn or use, and we're seldom surprised or frustrated while working with the program.

Next we will cover some basic elements of our editing process. Although we use FCP for demonstration purposes here, you can apply these principles to any NLE editor.

Setting up Your Editor
Scratch Disks for Video Caching

First of all, be aware that editing video at full HD (1080p) is taxing for your computer. Movies can take up a lot of storage and processing space, and there is no way to store everything in your computer's memory, even if your computer is high capacity. We recommend a computer with 4GB minimum, and the more the better.

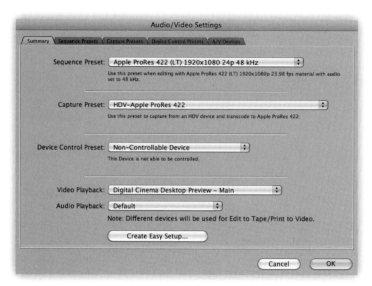

Project presets

This space-hogging issue means that the NLE program has to cache data on your hard drive, which also means that the faster the drive is, the better you'll be able to handle working with your movies. High-end systems use striped RAID arrays and very fast computer connections. We won't go into detail on these specifications here, but we recommend, at minimum, using the fastest drive on your system (but not the system disk) to assign the cache files for the editor. We use a regular 7200 RPM drive on our Mac Pro. If you use a MacBook Pro you may want to use a fast external eSata or Firewire 800 drive. USB 3 drives are coming soon, and we are sure they will be a welcome addition to the external drive arsenal.

Basic Project Settings (Your Defaults)

Project presets can be redefined with every new individual project, but it's key is to have a default preset that is as close as possible to your typical project settings. As shown in the illustration, we always use 1080p and Apple ProRes LT at 24 (or 30) fps for our projects. FCP 7 has an Open Format Timeline (more on this later) where you can mix and match clips with different formats. Settings for the first clip entered into the timeline define the settings of the sequence. All subsequent clips will be converted using these initial settings.

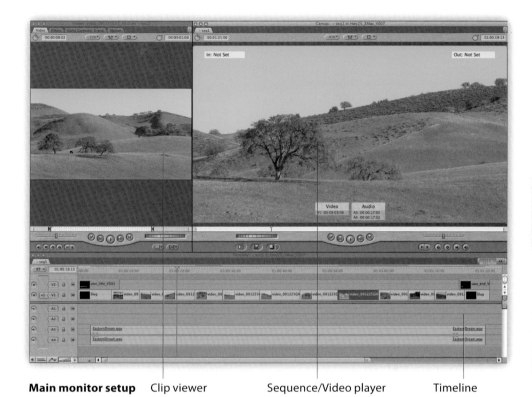

Main monitor setup Clip viewer Sequence/Video player Timeline

Basic User Interface (UI) Elements
FCP allows you to customize the interface in many ways. We work on a dual monitor system where we have the core elements (like the clip viewer) on the main monitor and additional support windows floating on a second monitor (tool palettes, browsers). We highly recommend this setup.

Main Monitor
- **Clip viewer:** view and edit your clips either from the timeline or the media browser

- **Sequence/Video player:** view the movie in its current editing state
- **Timeline:** docked on the bottom of the screen

Second Monitor
- **Media browser:** shows the media you added to your project (clips, sound clips, and images)
- **Effects Browser (the extra tab is the media browser):** helps to find and organize transitions and filters
- **Scopes:** tools to help judge frame tonality and colors

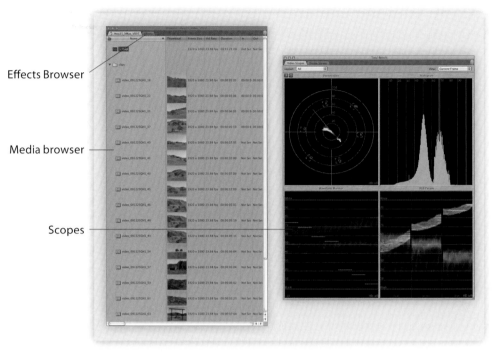

Effects Browser

Media browser

Scopes

Second Monitor setup

Having two monitors helps a lot during video editing. The main windows are on the first (bigger) monitor and the helper tools on the second one.

Selection Tool (keyboard shortcut "A"):
This is the standard mode. The cursor in ST mode is mainly used to select and move clips.

Ripple Tool (keyboard shortcut "RR"):
Trims clips on the timeline while preventing gaps.

Razor Tool (keyboard shortcut "B"):
Cuts clips into two parts. Don't overuse this tool.

Distort Tool: Enables distorting the frame for image alignment (e.g., correct perspective).

Tools Palette

New empty project
A new project is like a blank canvas. You "paint" your story here.

FCP allows you to store the layout of both monitors and recall it later. Depending on what you do during editing, you may have more than one layout you want to use for different tasks. On a smaller monitor it might get crowded; it's better to hide unused windows.

Tools Palette
We only use a few of the essential tools for our editing.

New Project
The presets we defined in the last section are automatically applied to any new project. The empty project screen is where you start solving your puzzle (creating your movie).

Import Assets into the Editor
First, we load our clips and other media files (from the project clip folder) into our project by dragging them into the media browser window. It's best to organize your media in the Media Browser using folders (called "Bins" here). Media includes clips, images, and sound files.

Media Browser

Shows media used
in the project

Once you have organized the media, drag the media files from the media browser window into the project folder. Don't change the names or content of existing files at a later time because FCP projects keep references to these media files, and renaming files or changing content will affect the reference and your ability to access the files. Adding or removing media files, however, is fine.

FCP also allows us to customize the layout of the Media Browser. We created one that shows clip thumbnails and the information we need most in the first few columns (codec, frame rate, etc.).

Timeline

The timeline is at the core of your editing process. Clips and sounds on the timeline represent the movie at the current state. To make finer adjustments you can zoom in and

Timeline

The timeline shows the story in the right sequential order

The play head can be moved in two modes:

snap: the snap tool on the far right shows green

no snap: the right tool shows gray

Play head

The play head shows the current selected frame in the movie

out. To view the entire movie on the timeline use Shift+Z—one keyboard shortcut you'll want to memorize.

The timeline actually shows a movie sequence. We normally create only one sequence per project, but there are instances where you may want or need multiple sequences.

As previously mentioned, the open format timeline in FCP adapts settings such as codecs and frame rates to the properties of the first clip you insert into the timeline; you will need to confirm them, though. This means if you want a 30p sequence but also use 24p clips you should add a 30p clip as your first clip, or vice versa.

The timeline represents your movie in two main sections, video and sound. Stereo uses two tracks, and both sections can use more than one layer. The function of editing is to fill and tune this timeline. You can usually see the result of your edits immediately, unless you use computing-intensive filters and transitions.

The timeline is scaled by TimeCode, which can be read as follows:

00.00.45:16: Position 0 hours, 0 minutes, 45 seconds; frame 16.

The maximum number of frames per second depends on the selected frame rate. Frame numbers range from 0 to fps-1 (e.g., at 24fp this means 0 -23).

Play Head

Every viewer window (clips or sequence) has a play head. The play head shows the current frame; the frame content is shown in the viewer window.

The play head can be moved in two modes, snap or no snap:

- **Snap:** In this mode, the play head snaps to the junctions between the clips. This is desirable in order to easily select positions for transitions or insert new clips.
- **No snap:** We use this mode if we need finer control over the play head movements.

Adding One Clip at a Time

Create your movie by adding clips to the timeline in any order you like. Don't worry, you can rearrange them at any time. But we've found that it is easier to have at least a rough idea of the order in which you want to tell your story, and therefore the order in which you want to use your clips. Your final storyline depends both on your intended story—your script—and the available clips. As we've mentioned before, re-shooting is not always an option and is rarely desirable, even if possible.

You can add a single clip to the timeline in several different ways; we describe only the one we recommend, which is to drop a clip into the clip viewer on the top left. Note that at this point the clip is not yet part of the timeline sequence.

You trim clips by setting an In/Out point for each clip. Reasons for trimming a clip include:

- You want to use only part of the clip, e.g., the one that fits your story.
- You want to use only high-quality material.
- You want make the clip just the right length, which is very subjective. Too short a clip may not allow the viewer to capture the essence of the scene, while too long a clip can be boring.
- You want to leave some space at the beginning and end of a clip to allow for adding transitions later, if desired. This area holds the so-called "Handles" (an FCP term) that are needed when you want to add transitions.

Once you have trimmed the clip you can add it to the timeline. The In/Out points can be changed later at any time.

In (I) and Out (O) points and Handles (red dots)

Controls shown during dragging the clip onto the main window

The different colored fields show different ways to insert clips into the timeline

Storyboard

The thumbnails of the clips get arranged from left to right and top to bottom

Position the play head at the point where you want to insert the new clip. For the first clip you add, it should be at the home position (keyboard shortcut, "home" key). We always use the insert option (see explanation below) so that the new clip doesn't hide other clips. When you drag the trimmed clip over the Video Viewer pane, the controls shown in the image on the previous page appear.

When you drop the clip onto the first yellow "Insert" field, the clip will be inserted at the current play head position, usually at the end of all clips or in between clips. If you insert your new clip into the middle of an existing clip, it would split that clip into two parts (an effect similar to using the Razor Tool). If you make a mistake you can undo it by using Command-Z.

Adding Multiple Clips at the Same Time

Adding several clips at a time is a good option if you are in a hurry, or simply want to get a number of clips into your sequence at once. You can use the Media Browser thumbnail view to create a visual storyboard.

Arrange your chosen clips in the order you want them to be on the timeline. When working with multiple clips like this, you define the In/Out points for each clip at a later

Using the Razor tool

Slug

Slug fills the timeline with black background and 2 empty stereo tracks. We use it here for our title scene.

The red dots mark areas that are outside the In(I)/Out(O) region and show Handles

time. Once you've selected your clips, drop them directly into the timeline. Pay close attention to where you place them. Again, if you make a mistake you can undo the action by using Command-Z.

Fine-tuning the Movie in the Timeline

Once your clips have been added to the timeline and the story is roughly in shape, the next step is to fine-tune your clips in the timeline (namely, refining each clip's In/Out points). We often use the Ripple tool (keyboard shortcut "RR") to trim clips on the timeline, which is advantageous because you avoid gaps on the timeline. Turn off the snap for the play head when using the Ripple tool.

You might assume that you'd use the Razor tool during editing; after all, don't you "cut" a movie? This is not the case, though—it's much better to use proper In/Out points for your clips. If you cut your clips with the Razor tool, they lose their proper relation to the original clips. We use the Razor tool (keyboard shortcut "B") mainly to cut audio tracks so that their length matches the related video.

PhotoMotion

A FCP plugin that helps animate still images

Transitions

Transitions are used in between clips, something that, in feature movies, you rarely see used. Bettina and I are still learning where to use transitions, and which ones make most sense. We've found that using too many transitions, especially abrupt or obvious ones, can make your movie look cheesy. Note that you need to set the clip to show "Handles" if you plan to add transitions in FCP.

FCP features many transitions. So far we have only used very brief Fade in/Fade out transitions.

Generators

These additions to your movie are called generators because they are "generated" footage, not recorded movie clips. You might use a generator when you want to add text or graphical overlays as you edit your video. As shown in the illustration on the previous page, we are adding a "Slug" in FCP with a predominantly black background. The Slug tool allows you to place text on top of it, something we use mainly for the title and end clips.

Making Still Images Move

One popular technique to animate still images is called the "Ken Burns Effect". Ken Burns did not invent this effect, but he used it very efficiently in his masterful documentaries. We use a solution implemented by the GeeThree "PhotoMotion" plugin for Final Cut Pro.

To begin, select an image, a start frame, and an end frame. In our sample on the previous page, the start frame shows the slightly cropped full scene and the end frame is zoomed in. The image is cropped because it has a different aspect ratio. The plugin will then generate all the images at the current frame rate over the time you set in the timeline in order to perform the zoom operation.

The process works best when you avoid images that are not too sharp. In fact, we blur these images slightly in Photoshop to reduce flicker. Also make sure that the zoom scaling is not set too fast.

The Ken Burns effect can also be implemented using tools in Final Cut Pro, but it is somewhat difficult, especially to keep up with changes to the images.

The Motion Tab

FCP features a Motion tab, not to be confused with the Motion application that comes with Final Cut Studio. Here you can do some basic (but very important) corrections, such

Motion tab

Note

The treated sequences may need to get rendered before using many of these filters. This takes time. It may make sense to do these more intensive operations at the end of the process so that they don't interrupt your editing flow.

Note

It is important to keep in mind that the "identical" clip shown in both the Media Browser and the Timeline may have different In/Out points as well as different filters assigned to them. Both of these clips point (refer) to the same original clip in your clips folder, but have different instructions attached. That is why you need to edit clips in the Timeline or the Media Browser—do not edit the original clip from the clips Bin.

Crop and Zoom

Note that the zoom can be edited directly in the viewer area

Correct Perspective (using Distort tool)

Filters tab

It shows all the filters used for a clip and allows you to change the different parameters for these filters.

as Zoom and Crop as well as Distort. There are also other tools, but these are the ones we use most.

All transformations need to be done in moderation: if your original footage is 1080p (or just 720p), the image quality will become degraded.

Corrections

Once you have all your clips in place it is time to fine-tune them using some of the many filters in FCP. There is also a large third-party market for FCP plug-ins, just like for Photoshop. We only discuss those tools and filters that we use the most for our short videos.

To add filters to a clip on the timeline, it's best to first drag the clip from the timeline to the clip viewer, add the filter, and then return the clip to the timeline.

The filters are accessed under the Filter tab. The filter parameters for most filters are shown in this list. Some more complex filters have either dedicated dialog boxes, or, like "Color Corrector 3-Way", their own tabbed pane (see Color/Contrast Corrections, on the next page). The Filter tab can also be used to delete or disable filters.

Following are filters that we use all the time.

Stabilization Processes: Smoothcam, Motion, and Magic Bullet Steady

If you captured your clips hand-held you may want to add some stabilization in software. Final Cut Studio comes with two tools we use frequently, the Smoothcam and Stabilization (as part of the Motion program, not the tab shown above). We also use Magic Bullet Steady.

Color Corrector 3-Way
The basic color correction tool in FCP

The stabilization process occurs over two steps, Analyze and Render. The Analyze step tries to discover how the frames would be optimally aligned, and uses processes including move up/down, rotate, and scale. The Render part of the process performs the needed transformations and scales up (if auto zoom is selected) to avoid black borders.

In our experience, these tools significantly reduce the effects of shaky original video clips, but they can also introduce artifacts. Some of these artifacts are caused by the rolling shutter of the DSLRs. This is another reason why it's best to use a tripod whenever possible.

Color/Contrast Corrections

One of the key tasks in the editing process is to correct colors. "Correct" is somewhat of a misnomer in filmmaking; it refers more to the process of creating on film the look the filmmaker had in mind, matching vision to reality as it were. Final Cut Studio comes with a complex, dedicated application called "Color" to aid in this pivotal editing task. So far we have not checked it out, since it seems very resource-intensive (using a lot of memory) as well as complex.

The basic color correction tool in FCP is the "Color Corrector 3-Way". Color Corrector 3-Way allows corrections in three different areas:

- Blacks (define your black point)
- Mid tones (a key region)
- Whites (modify the extreme highlight regions)

This is clearly a powerful tool, and you must be careful not to perform overly strong corrections. Remember that because of the strong

The different Video Scopes

compression in DSLRs, we don't have as much latitude as we are used to with our RAW still images.

With still processing you often use the Histogram to analyze your image, helping mainly in the shadows and highlights. The mid tones should always be judged visually. FCP has different tools for these processes called "Scopes".

A video should never have clipped blacks or clipped highlights. Of the four scopes available, we mainly use the one in the bottom right, RGB Parade, for adjusting highlights and shadows.

The top highlights should not reach the 100% (White) line, and the blacks should not go all the way down to the 0% (Black) line.

The Vectorscope can be helpful for color casts. There is a special line at about 10:30 (looking at the scope like a clock). Normal skin tones

Adding title text

We use a very simple yet effective form to add a short title sequence.
It is also important to select a nice font.

would be close to this line, while the points further away from the center represent more saturated colors (this means that a B&W frame only shows a single point in the middle).

Also remember that the color distribution in a video can change from frame to frame. In addition, if you plan to show your video on TV (for example, playing directly on your own TV), you also have to watch for TV safe colors.

Sharpening

Sharpening can be tricky with video because of the low resolution and highly compressed images. Avoid strong sharpening as it will create

halos and result in a poor quality movie.

Other Plug-ins (FCP FX Plug-ins)

There are a huge number of filters for FCP. We suggest that you first try making a nice movie using the basic tools, and only look into advanced features when you really need them. Most external filters slow the workflow quite a bit because they often require more computer intensive rendering.

Overlays and Blending

You can also overlay different video tracks and blend the images. Later in the chapter we cover how you can

Magic Bullet Looks

Here we used Looks to create a black and white movie that features a vignetted view

use Photoshop Extended with video editing—all your favorite Photoshop techniques are available.

Titles, Text, and Credits

Creating title and credit sequences is an art form in itself. Sophisticated sequences can be generated using Motion (the Final Cut Studio application) or other tools. For now we use the simple Text tool as a layer on top of a black Slug.

The Text tool can use any fonts installed on your computer, and the text can easily be positioned inside the frame.

Creating Your own Look

Some of the more popular tools for creating a unique visual look for your videos are Magic Bullet Looks and Mojo (by Red Giant Software).

Magic Bullet Looks (the more advanced version of the two plug-ins) features a very innovative user interface that makes it fun and easy to use. In the example shown above, the plug-in has converted the video into black and white and added a nice vignette look. Magic Bullet Looks also allows you to store your own presets and reuse them later.

Adding Sound

Adding good sound is at least as challenging as obtaining good images and editing them into a great-looking video. All you have to do is play a movie with and without sound to realize the importance of the audio track. We generally use a music track as sound accompaniment for our videos, selecting music that enhances the mood of the movie.

Be sure you have the license rights for the music you choose, so you don't violate copyright. Here are some useful sources:

- Garage Band (make your own sounds)
- Free sounds
- Royalty free sounds from Final Cut Studio
- Custom sound (e.g., we recorded live cowboy music for one of our videos)
- Mix with recorded sounds (e.g., birds, if part of the scene)

The Panasonic GH1 allows you to record decent stereo sound with its built-in microphone. Because the GH1 14–140 mm kit lens is silent (AF and image stabilization), the results are usable. An external microphone would naturally be the best option. Most other DSLRs currently feature only a mono built-in microphone, and AF/Image stabilization features add a lot of noise, making the audio undesirable. We still recommend recording sound while filming because it may be useful for synchronizing external sound later.

Here are some other options that we haven't explored yet:

- Mixing audio
- Creating a voiceover
- Mixing recorded and canned sound effects
- Synchronizing sound to video (with a tool like Plural Eyes)

Export Your Video

You'll want to export your video either for further processing in other applications (e.g., Photoshop CS4 Extended, or later version of same) or for presenting to an audience. Which output codec to use depends on your target device or application. For further processing you need to use the highest quality codec possible (e.g., Apple ProRes HQ).

If you want to present your movie to an audience, there are at least two options. You can produce the final compressed version (e.g., for the Internet), or prepare a version for Blu-Ray or DVD production. For Blu-Ray, you should use a high quality codec; otherwise you may end up compressing twice because the Blu-Ray rendering process is compressing again.

For the Internet, using an H.264 codec is the norm. We use Quicktime

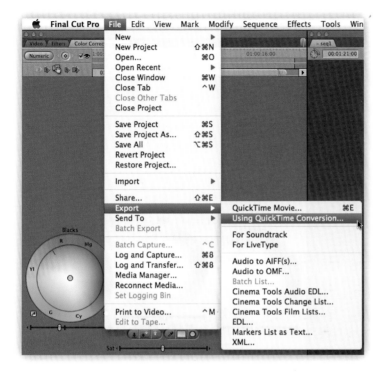

Export

We use Quicktime
Conversion for export

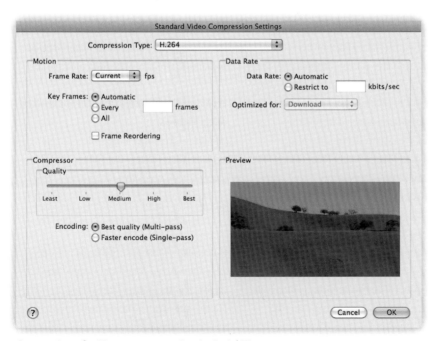

Our settings for H.264 compression in QuickTime

The different QuickTime settings
We change "Settings..." (compression),
Size, and Sound here

Conversion for export. Here are our settings for the compression:

The Quality setting "Medium", as shown above, produces videos acceptable for many purposes and results in smaller files. If you want better quality, use the quality setting "High" or even "Best". The resulting higher quality movie files will be much larger. There are further settings for:

- **Size:** We often downsample to 720p although nearly all our movies are shot in 1080p.
- **Sound:** AAC seems to work very well with Internet services like Vimeo and YouTube.

Recently we also started to export to the Apple TV format. This works fine with the Internet and some media players (Apple TV and Western Digital Media Player, to name two).

Post-Processing and Adding Effects

The dominant effects application is Adobe After Effects. We personally have not dived into it; as mentioned before, we learn one step at a time.

Working in Photoshop CS4 Extended with Videos

We were surprised and pleased at how powerful video editing in Photoshop CS4 Extended can be.

Note: You need the "Extended" version of Photoshop CS4.

Working with video in Photoshop CS4 Extended is surprisingly easy. Open the video (exported from your NLE program in best quality) and show the Animation window. This allows you to step through the video

Working with video in Photoshop CS4 Extended

We converted the video stream to a Smart Object. This allows us to use CS4 Smart Filters. The following settings of "Unsharp Mask" (used as Smart Filter) enhance the local contrast.

frame by frame or play the clip at reduced speed.

You can work with layers just like you would for still photos in Photoshop. As long as you use only Smart Filters and Adjustment Layers, these settings will be applied to all frames on Export. Be careful when using masks because they need to be the same for all frames in the clip. Once you have found the right settings, you can render the movie by using File -> Export -> Render Video.

We feel at home with Photoshop and love having this much control.

Showing Your Videos

Presenting Your own Movies

There are many ways to present your own movies:

- Mac or PC
- Internet
- Blu-Ray
- HD Video DVD
- Media players: Apple TV and Western Digital Media Player

Mac or PC

Most HD videos play well on modern Macs or PCs. The downside is that you can only have a few people sitting in front of a monitor, and that had better to be a big monitor.

Sharing over the Internet

If you don't want to host your own videos on a server it is best to use one of the major video sharing sites. We use the following three services:

- **YouTube (youtube.com)**
 YouTube is essentially a general video site with little focus on filmmaking. We use it mostly for technical demo videos.
- **Vimeo (vimeo.com)**
 Vimeo is a movie-sharing site for filmmakers. We post our movies here if we think they have some artistic merit and/or to get feedback from other filmmakers.
- **SmugMug (smugmug.com)**
 We host all our still online galleries at SmugMug. SmugMug can also host videos. If you have a Pro license, the user interface can be customized and looks very professional.

Export Your Movies for Internet Sharing

We export our videos in H.264 format if we want to upload them to one of these services. The conversion is basically performed with QuickTime 7 Pro; a middle quality setting (resulting in smaller files) is usually good enough. We also downsample to 720p because otherwise many people may not be able to view the 1080p movies, which demand more bandwidth.

If you upload to Vimeo be sure to use a good title frame because that is what viewers see first.

Playing Your Movies on Your HD TV

- **Blu-Ray:** Burners and media are still quite expensive. If you burn a Blu-Ray disk, Toast 10 Platinum is a good choice for authoring the disk.
- **HD Video DVD:** You can also use Toast 10 Platinum to burn HD footage on normal DVDs (limited to about 30 minutes, though, which is long). These DVDs play on many Blu-Ray players. You most likely already have a DVD burner in your system; also, the media are cheap.
- **Media Players:** Apple TV and the Western Digital Media Player make it easy to watch HD content on your TV. The Western Digital Media Player can play movies from USB drives, which means there is no need to burn a DVD (especially important for testing).

Conclusion

Moving from still photography to making videos has a steep learning curve, but once the basics are mastered it can be a lot of fun. Will it distract you from taking still photos? Perhaps, but we didn't really find it to be so. We like both video and taking stills, and don't feel that our still photography has suffered from lack of attention. Without the DSLR we wouldn't attempt video, though, because carrying two sets of cameras and related equipment would be cumbersome. However, not only are we (and our backs) spared that burden, we are rewarded for capturing videos with the DSLR because it produces a more filmic look, better even than expensive professional video cameras.

We urge you to experiment, have fun, and reap the rewards of this stimulating and creative venture of capturing digital videos. We have certainly found it rewarding!

Useful Links

Camera and Lens Manufactuers

- Canon USA –
 www.usa.canon.com
 www.usa.canon.com/consumer/
 controller?act=ProductCatIndexAct
 &fcategoryid=111
- Nikon USA –
 www.nikonusa.com
 www.nikonusa.com/Find-Your-
 Nikon/Digital-SLR/index.page
- Panasonic USA –
 www.panasonic.com
 www2.panasonic.com/consumer-
 electronics/learn/Cameras-Cam-
 corders/Digital-Cameras/
- PENTAX USA –
 www.pentaximaging.com
 www.pentaximaging.com/slr/
- SIGMA USA –
 www.sigmaphoto.com/
- TAMRON USA –
 www.tamron.com/
- Tokina – www.tokinalens.com
 www.tokinalens.com/products/
 tokina/index.html
- Zeiss – www.zeiss.com
 www.zeiss.com/photo

Accessory Manufactuers

- Audio-Technica Corporation –
 www.audio-technica.com
- Audix Microphones –
 www.audixusa.com
- BeachTek Inc – www.beachtek.com
- Bogen Imaging USA –
 www.bogenimaging.us/Jahia/
 home_page
- Chrosziel – www.chrosziel.com
- DPA Microphones –
 www.dpamicrophones.com
- Epson – www.epson.com
 www.epson.com/cgi-bin/Store/jsp/
 projectors.do
- Glidetrack – www.glidetrack.com
- GOSSEN –
 www.bogenimaging.us/Jahia/
 Gossen/site/bius
- Joby – joby.com (Gorillapod)
- Lastolite Limited –
 www.lastolite.com
- Lensbaby Inc. – www.lensbaby.com
- Manfrotto – www.manfrotto.com
- Miller Tripods –
 www.millertripods.com
- Monochrom –
 www.monochrom.com (lenses)
- Pod – www.thepod.ca
- Redrock Microsystems, LLC –
 redrockmicro.com
- RØDE Microphones –
 http://usa.rodemic.com/
- Roland Systems Group U.S., Edirol –
 www.rolandsystemsgroup.com
- Sachtler – www.sachtler.com
- Sennheiser – www.sennheiser.com
- Singh-Ray – www.singh-ray.com

- Sony – www.sonystyle.com
- VariZoom – www.varizoom.com
- Zacuto – www.zacuto.com
- Zoom Corporation –
 www.zoom.co.jp/english/
 index.html

Software Manufacturers
- Adobe Systems Incorporated –
 www.adobe.com
 www.adobe.com/products/
 premiere/
- Apple Inc. – www.apple.com
 www.apple.com/ilife (iMovie)
 www.apple.com/finalcutstudio/
 finalcutpro
 www.apple.com/finalcutexpress
- Cineform (Neoscene) –
 www.cineform.com
- Corel Corporation – www.corel.com
- CyberLink Corp. –
 www.cyberlink.com
- www.dofmaster.com
- MAGIX AG – www.magix.com/us
 www.magix.com/us/movie-edit-
 pro/plus/
- Pinnacle Systems –
 www.pinnaclesys.com
- Red Giant Software –
 www.redgiantsoftware.com
- Sony Creative Software –
 www.sonycreativesoftware.com
 www.sonycreativesoftware.com/
 moviestudio

Music and Sounds
- www.soundarchiv.com
- www.sonosoundfx.com
- www.sonoton.com
- www.sound-pool24.com

Information, Tests, Forums and Blogs
- www.cinema5d.com
- www.dvxuser.com
- www.moviesphere.com
- www.prolost.com

Sample Videos
- www.mediastorm.com

Index